some thing from no thing

RotoVision

A RotoVision Book
Published and distributed by RotoVision SA
Rue du Bugnon 7

CH-1299 Crans-Près-Céligny
Switzerland

RotoVision SA, Sales & Production Office
Sheridan House, 112/116A Western Road
Hove, East Sussex BN3 1DD, UK

Tel: +44(0)1273 727 268
Fax: +44(0)1273 727 269

E-mail: sales@rotovision.com
www.rotovision.com

10 9 8 7 6 5 4 3 2 1

ISBN 2-88046-547-8

Design by April Greiman

Production and separations in Singapore
by ProVision Pte.Ltd.

Tel: +65 334 7720
Fax: +65 334 7721

Printed in China

april
greiman

and

aris
janigian

some thingfromno thing

thing

6 Foreword
8 Introduction

14 From Depth to Surface

16 Deeper in the Field
18 What a Body Is
20 Unfurling the Flag

32 The Matter of Time
36 Joshua Time
40 Bodies of Color
46 Natural Circuits
50 Stepping Into Landscape
56 The Function of O

64 Atmosphere

70 The Real
78 Real Spaces
112 Miracles

144 About this Book. How to Read it, etc.

156 End Notes
157 Bibliography
158 Projects / credits / other facts

Throughout the book, folio numbers on the left indicate the beginning of a new section. Image numbers on the right are cross-referenced to detailed credits on page 158.

Flip book sequence on right-hand pages from 'Aspen Design Conference, the more things change... 2001, Selby Gallery digital video' (excerpt).

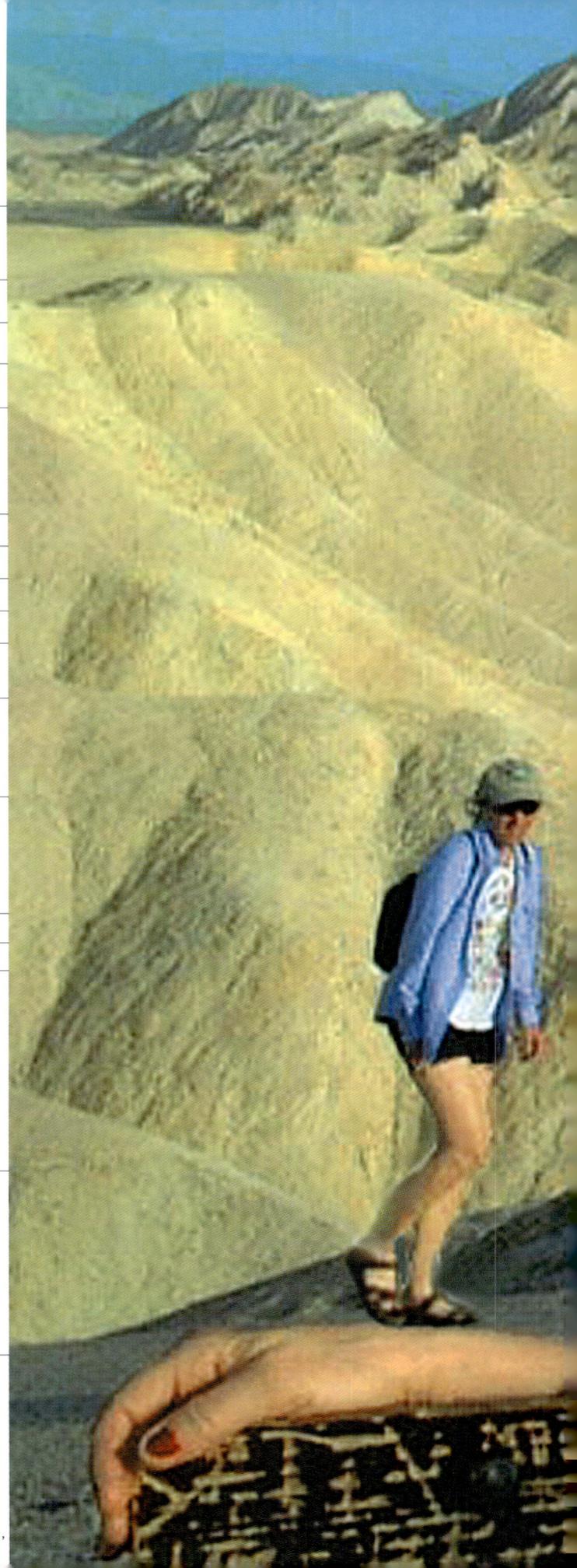

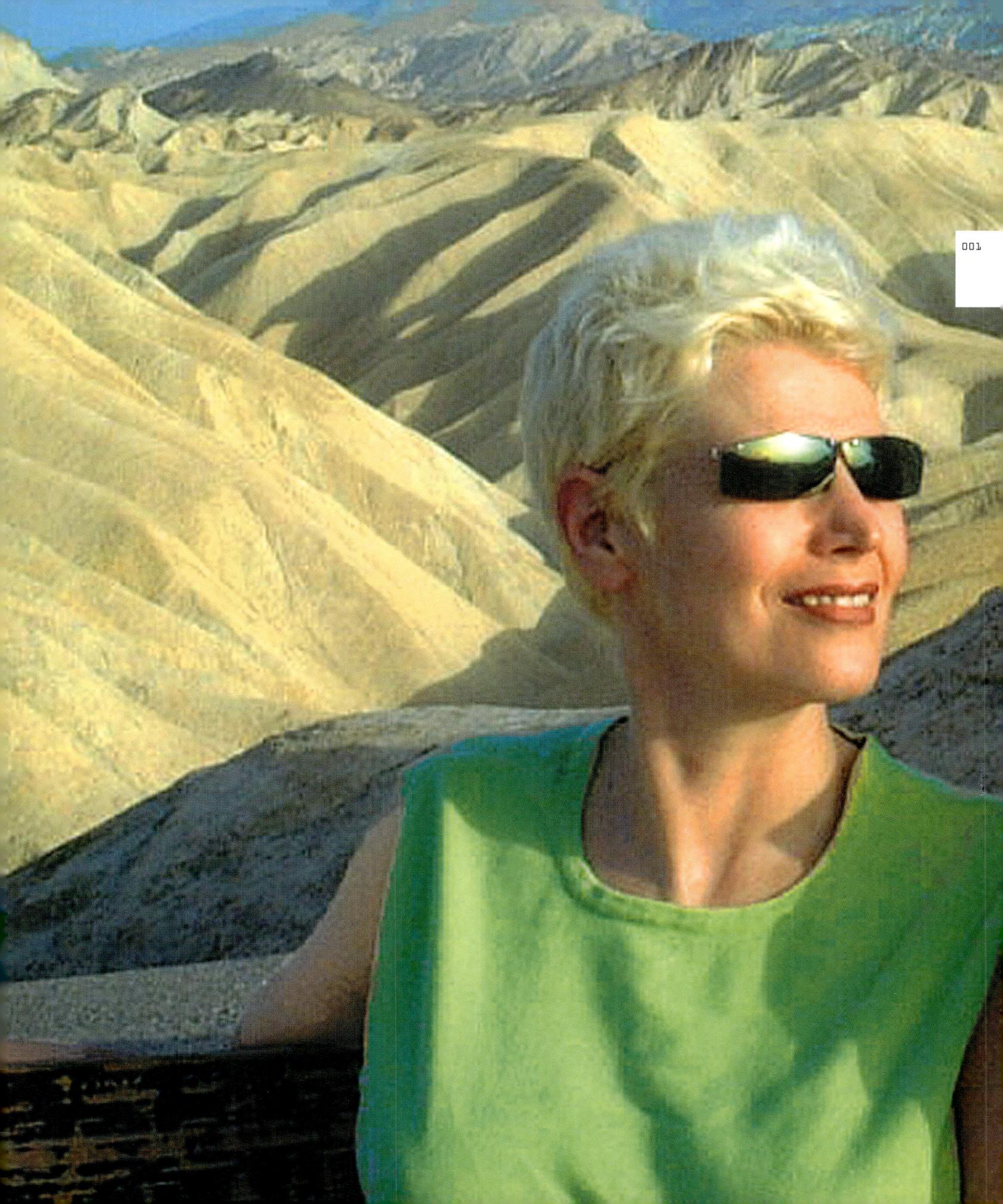

by lewis blackwell

I'vebeenlookingandreading, like you, and also pulling out some reference and thinking. And there comes the question, what is the subject of this book? It is a woman I have met. A woman who is a reference point in graphic design history. She could also be labelled a prophet, a teacher, a hotelier, an environmental artist, a businesswoman, a technophile and a technophobe. The list could run on. Her work has been filed under many tags in the shifting library of design theory: see the empty space left on the shelves of Basel school, New Wave, post-modern, LA-style, techno-futurism, post-structuralism to deconstruction, and over there an ism I can't yet read. So many influential contributions and suggestions of association—it would be easy to open a new section, set aside another shelf, another label. But this would be an inadequate response, one at odds with the connecting lines drawn through the work.

April Greiman is a place.

No, at least two places. Isolated points on the map, somewhere in the desert back of Los Angeles. So we have this drive across the scrub and rock and unearthly beauty. We start below sea level, where it is warm in winter and testing in summer: the cultural and commercial life ebbs and flows, but there is a strong identity to the streets whatever is being transacted. We end at 10,100 feet with a view that inspires and an atmosphere that can be challenging to consciousness. Here we are less certain of the space, there is an impermanence that leaves us always looking, always unsure that we have found the centre... perhaps there is no centre and that is OK. Our desire for resolution is the problem. Elevations and populations go from less than one towards the infinite.

That is onewayofseeingtheonedimensionofthegraphicspace. And April's is, of course, another.

In what must've been **the fourth or fifth grade,** my civics teacher gave our class a delectable assignment: make a collage of cut-outs from magazine ads. Even though we knew that magazines were the trashy stepsister of 'real books,' there was still a family resemblance there that gave me a perverse thrill when I ripped into them, cannibalizing images, violating borders, orphaning texts. Trash swelled around me. Arranging the crop was nearly as much fun. Those things (a head, a foot, a smile, a letter, a word) which had always had a fixed presence, now seemed infinitely mobile and free. I remember confounding expectations by gluing the word 'Master' over the picture of a dog, or shuffling typefaces of letters around, or splicing together words like 'Fun'(ny) and (sun)'burn' to get the neologism 'Funburn.' Stuff like that. I can only guess at what the teacher wanted us to learn. Maybe she felt that magazines contained information about our social world that we could somehow cull from this practice, or could be she meant us to assemble a kind of critique of pop culture by disassembling its ads. However, what was indisputably clear to me and my classmates was that magazine ads, reflecting the desires and jags of culture, were disposable, unlike true art, hardly worth the dustbins they were destined for.

Graphic design hasn't fared much better in the scholarly world. Because the work of graphic designers is squeezed between the demands of the client and the needs of the consumer, it is usually judged empty of any artistic integrity. Designers are, as social psychologists put it, *externally motivated*, while artists are, by contrast, *internally motivated*. There is little scholarly writing about graphic design, though there are a number of cultural critics who might use graphic art for fodder in lectures about sexual exploitation, race relations, global capitalism, etc. In the end, even if the work of the graphic designer is admired, or critiqued, it is hardly ever studied. I suppose it doesn't help that the designer labors in a kind of nameless zone—her identity is subsumed into logo, or poster, or whatever. Indeed, a serious book about graphic design demands a degree of justification for taking it so seriously. Why **this prejudice?**

8

Why?

Especially when we consider that a vast majority of art left us over the millennia was produced by just such nameless laborers in the service of a force (e.g. God), or royalty (e.g. A King) or client (e.g. A guild)? I would not go so far as to argue that advanced capitalism has turned the consumer into a God, and that we must now trumpet graphic designers as the new Giottos—I'm not suggesting that kind of extreme parallel. I'm also not suggesting that on the whole graphic design, whose production is prodigious and everywhere, contains the same degree of complexity as does Art proper.

But, in looking forward a bit, I *would* suggest that graphic design, because of its close relationship to culture, has actually been freer to experiment with its images than has Art Proper.

But back to the prejudice. To understand where it arose, we must look into the peculiarities of modernity (economic, political, philosophical) more deeply than I am up to doing here; but at least I'll try to sketch below the philosophical contribution to this condition. Since the beginnings of Western philosophy, 'disinterestedness' from external demands and affairs has epitomized the truth-seeker. For Socrates, reason alone is capable of washing away the biases and prejudice and customs—the all too human interests—that obscure the ultimate truth. Unless we assume the philosophers' approach, we must accept the skeptics' world of flux and uncertainty and the ultimate rule of power.

Where is the seat of this interest? Plato's answer is the body. The soul sees clearly, but upon assuming a body at birth it is forced to 'forfeit' this clarity. Truth-seeking requires flaking off what one has learned since birth until the ultimate truth shines through. The Apostle Paul wed Plato's concepts to the Jewish dream of a God-centered community anticipating the arrival of the redeemer; for Paul, the spirit is sanctified by drawing close to Christ. This requires rejecting nearly all worldly concerns, especially those appealing to the body.

The Middle-Ages were illuminated by fiery debates about God, how to best protect His exalted nature from the rising tide of rationalism on the one hand, and from the debasing undercurrent of personal interpretation, on the other. By the 13th century, Meister Eckhart argued that believers had all but lost track of God's essence, in spite of their total observance of his commands. Christians had personalized God to such an extent that He had become nothing more than a petty mirror image of their own interests. Knowledge, humility, mercy barely touch the sleeve of God because they involve a degree of attachment to one's own 'ego.' Behind the God that we claim to 'love,' sat what, or whom, Eckhart named 'The God Head,' that which 'reposes in naked nothingness' and is nameless, unreachable, unthinkable, totally beyond our grasp, and whose essential nature is total immutable detachment. How then are we to attain God? Eckhart's answer, which has a definite Buddhist resonance, is, when we commit ourselves to not attaining him. Only when we are detached are we able to have communion with He whose nature is detachment.

Nearly six centuries later Kant was still under the sway of this pivotal concept of detachment or disinterest in his formulation of what characterizes moral judgment, and more importantly for our purpose, in his formulation of what characterizes aesthetic judgment. In his critique of aesthetic judgment, Kant begins an inquiry which has as its goal the question of what distinguishes judgment of art from other types of cognitive judgments. For Kant, when a person makes an aesthetic judgment he believes that judgment to be universally valid, good for everyone—the beautiful being not just a matter of personal taste, it is something essential that inheres in a thing. But is such a judgment warranted? Does beauty possess a universality in the same way as do scientific facts about—for instance—the natural world? Can we say this or that painting is beautiful with as much certainty as we can say the stars or the moon exist? Kant's answer occurs at two levels. The first level addresses the work of art itself. Art (representational art) seems to possess something like the internal order and purpose that nature possesses. In a painting of a rose, all the components (the petals, stems, etc.) appear as though some underlying force were organizing it. However, in fact, the painting is only a kind of illusory ordering of reality, possessing what Kant famously described as "purposefulness without purpose." Is our aesthetic judgment then merely subjective? Do we know it according to our individual likes and dislikes, the same way we do furniture or food? Kant's answer, which now shifts to the level of the observer, is "no." Aesthetic judgment involves a special order of subjectivity found nowhere else in matters of personal taste, indeed it is a type of subjectivity closely resembling what we know when we are faced with a moral decision. This subjective state is one of disinterestedness in relation to the Art object. Just as we are required to act without thought that which "gratifies or grieves us" when making a moral choice, so we act without selfish interest in making aesthetic judgments.

This turn in our understanding of Art, which occurs at the end of the 18th and beginning of the 19th century, corresponded to a shift in three major realms of social life: the economic, with the emergence of corporate capitalism; the political, with the advent of democracy; and in religion with deism, skepticism, and at an alarmingly swift rate of growth, atheism. Each of these realms brought with them an increasing secularization of social life, and a greater degree of freedom. But this freedom, whose norms were based upon a rational calculation of personal or social interest, was purchased at the cost of the sacred in all of its manifestations: the punitive, the merciful, the beautiful, the sublime. It is into this absence, in an attempt to recover that lost ground, that Art jumps. As we've seen, in his Critique of Aesthetic judgment, Kant had already engineered the springboard for this romantic leap. Implied in his critique was a revolutionary notion of Art (which now warranted the capital 'A'): that of a semi-autonomous sphere of human activity, detached from

both the rational interests that governed human affairs, and the universal laws that governed science. Art, for the Romantics, possessed a kind of visionary, or even spiritual power. Schelling, Hegel, and Schiller fought to raise an altar for Art that could both stand above and provide a critique of religion, science, and capitalism, and even, to a degree, democracy—base systems whose sole end was to adapt the world for practical interests. Securing this position required going one step further than Kant and carving out a place for Art outside the economic (in the broadest sense, that which is based upon rational calculation and is involved in the maintenance of the human) realm. For instance, Hegel, in his Aesthetics, charges himself with exhuming, as the first instance of architecture, a building disinterested from economic matters, and whose purpose seems wholly internal to itself. The usual candidates; hut and temple, the dwelling places for man and God, are disqualified, and instead Hegel nominates the Tower of Babel, which he describes as an "inorganic sculpture."

A generation later, Schopenhauer went so far as to claim that through the detached and disinterested 'contemplation' of a work of Art, we gain a window onto the "permanent essential forms of the world and all its phenomena" which would otherwise remain hidden from us. The young Nietzsche turned the screw still further. He held that the artist is the only maker who is fully cognizant of his "Will to Power," that is to give form to things. In this way, the Art object is the purest reflection humans have of themselves. Now Art is the Real, and the Real itself is a chimera, a shadow play on the walls of a cave, the images of which emanate from the very brains of the observers.

Modernity is characterized by the monumental shift from the question, 'what is the nature of reality?' to 'what is the nature of the devices that we use to construct reality?,' a question that artists seemed particularly eager to answer. Picasso and Braque, with a kind of mad gusto and near-pathological self-confidence ("I am king," proclaimed Picasso when he was still a child) proceeded to explode the inviolate relationship of the viewer to the viewed into a thousand splintery perspectives; and each perspective,

it seemed, spawned yet another artistic perspective. Through the last century, slowly but surely, as they say, every aspect of the Real was cavalierly divested of integrity by artists. However, a certain anxiety surrounded these manic efforts, for the discovery that the Real was made, not found, placed a tremendous burden on the artist whose only route out was an ever-deepening probe back into his own nature and his own devices. Art might be able to lead the way, but in the absence of a world out there to refer to, once again the question became 'which way?' and 'whose way?' The 20th century, famous for its -isms, was marked by a hundred different responses. In the art world, manifestos were lobbed back and forth (if there isn't a world out there anymore to conquer, than how can we know we are advancing, other than by killing our own kin?). Duchamps, perhaps, was the first to see an abyss where others saw Eden—or at least a bridge towards it (the same abyss, I imagine, Eckhart must have known when six centuries earlier he asserted we "take leave of God" in order to find Him). For Duchamps, art was a set of arbitrary conceits, a kind of self-flattering machine for producing the world. But his cynicism would not easily stick. A generation would pass before the specter that haunted artists of the last century finally came home, with Warhol, to roost.

Warhol takes Art to court. His charge: hubris. What else do the flat and mechanical (the machine's greatest merit is its absence of 'interest') methods of production behind Warhol and his Factory signify—other than a kind of punishment upon art for holding itself in such high esteem? For that matter, Photo-realism is a push that makes not so much reality, as art, superfluous. In this context, our old friend Disinterestedness came to mean not taking your own work, much less yourself, too seriously. This, the perennial attitude—if not virtue—of pop culture now became Art's defining attitude—if not virtue. Which prompts the question: if I have plenty of the real thing, tell me why I need an ersatz, that is, art? Since the sixties and seventies, Art has had a difficult time selling itself to itself outside of an attack on itself. Sadly, from Ruscha to Sherman to Koons, art has continued a suicidal course, at its worst amounting to little more than a series of apologies for its very existence.

I'm sorry if my fast and dirty reading of Art throws up more blank space than it fills in. All I'd meant to suggest in this introduction is that in its search to secure an autonomous realm for its own existence, a realm detached from the exigencies of 'the real,' art has pinned itself into the corner of a room that Graphic Art was never invited into to begin with. And although art today is expressly secular in its concerns, it is at bottom engaged in a classical, spiritual quest that relies upon the negation of the world for its forward movement, whether this negation involves the body, society, God, or finally art itself. When this point has been reached, only repetition can take its place.

Graphic Art has proceeded in a different way. Because of its contingent relationship to culture, it has always had to work with it, inside of it, besides it. Graphic Artists have never had much of a choice other than to admit an interest in reality, they were never afforded the luxury of an ego turned in upon itself. They have had to finely tune themselves to the language, symbols, icons, speed, and the oscillation of a culture. By the same token, Graphic Artists have never been able to draw a long enough view to harden into a movement, ideology, or politic. Disinterest, far from damning, may have saved Graphic Art from the fate of Art proper.

FromDepthto Surface

The West is characterized

by depth writing. What I mean is that the ideas and concepts—the deep, eternal stuff—are what is important, not the surface upon which they are inscribed. The Word from on high is stamped on stone, papyrus, parchment, paper, screen—all neutral, empty, without energy and always only in a feminine state of wanting and waiting. Indeed, for Socrates, once the Word was written, once the dialectic condescended to a surface, its power was already compromised. The surface was merely the thing that carried the message beyond the sender and made the word present for bodies which were not present when they were spoken. The surface was a medium inside space and time conveying ideas outside space and time. Christ likewise eschewed the surface. For him, no surface except for the heart was necessary. Christ broke the stone tablet and whatever was written was superseded by the law of the heart, the 'invisible' surface that held the message fast inside.

By now we are all aware

of what lay in store for the depth model, and how, at the end of the 19th century the surface, and everything written on it, became of supreme importance. To be sure, we must amend our notion of surface from that upon which something is written, to the context, a site where events occur, the way the earth, or a battlefield, or a cityscape is a surface. Or, for Foucault, the body, which he describes as "the inscribed surface of events."[1] This surface, then, is a memory recorder, a place where histories are traced, where the dialectical purification of thought toward transparent understanding is eschewed for the inclusion of things to the point of chaos and madness, and where the search for an origin, an eternal beginning, is superseded by a microcosmic accounting of an always present ending. (For a visual, think Bruegel or Bosch). By meticulously accounting for surface forces, Nietzsche was able to do a genealogy of the values of man. Freud, who allowed dreams, slips of the tongue, and jokes into the analysis of the surface, was able to trace the pathology of an individual or even an entire society. In painting, the breakdown in perspective, the elevation of base into sacred material, the abandonment of representation, are all symptomatic of a more general shift from depth-to-surface relations. Collage opens up the field most directly; in its early days everything gets thrown into the sink. The poet Charles Olson, following Ezra Pound, rethinks the poem as an organic and open field where, "all the syllables and all the lines must be managed in their relation to each other."[2] This paradigm shift reaches even into empirical psychology with Kurt Lewin, who abandons the standard scientific approach that relies upon derivations from primitive to more complex facts, in favor of what he called "field conditions."

model for a moment. From its perspective, the world is always—to a greater or lesser degree—a chimera, a shadowy 'double' of what we will one day truly see. In *I, Corinthians 13,* Paul encapsulates the spiritual ethic of the West from Socrates to Hegel: "we know in part and we prophesy in part; but when the perfect comes, the partial will be done away... for now we see in a mirror dimly, but then face to face; now I know in part, but then I shall know fully just as I also have been fully known." Aligned with this belief is, Paul tells us two verses later, "hope, faith, and love." Hope rejects the present in anticipation of a future state of redemption; faith brings near the vehicle, Jesus, to that future claim which seems so impossible to reach; and love, which Paul claims is the greatest virtue of the three, helps us realize in small measure what we will someday receive in full. With this model, (what I will call) The Real is always virtual, in a state of waiting. Our anxiety over its not being with us is mastered by hope and faith.

The field redefines our understanding of The Real in two ways.

First, everything is already immanent in the field. The Real is always already with us. There is no aspect of The Real that is waiting to arrive. The Real is a closed book, completed, though it may take work (historical, psychological, genealogical) to establish just how the book reads. Two, anything that occurs in the Real can be explained as a result of the dynamics of the field. There is no dimension supplementary to it, no key held at a distance which unlocks its mystery. This all but drives a stake into faith and hope, which explains what Nietzsche characterizes as the rampant "nihilism" of the modern age. The only virtue that survives the old model, I believe, is love. Love brings into actuality, makes present from out of the virtual, a dimension of that deferred world. If we love well we are already in the bosom of The Lord, because love allows us to partake of the character of that which knows us perfectly.

In terms of knowledge, the field poses a problem, a paradox even: if there is nothing outside of the field, from where we can look to solve the problems in the field? Where with the depth model a single referent that resided on the other side of human affairs provided the ultimate basis for proof, with the field model all referents are circumscribed within the field. For instance, in the physical sciences, tape-measured distances and triangulated distances may be shown equivalent by the use of a third measure such as Euclidean relationships. But this, then, requires that Euclidean relationships remain outside the field. In Ethics, if everything is 'context,' then there can be no normative reading of anything in the field, because there is no way to get outside of the field in order to read it. Unless someone not 'invested' in the field shows how the surface articles are ultimately arranged, in terms of knowledge, the field, full of everything, appears empty (nihil). In all major fields of investigation, including philosophy, physics, psychology, history, this is the chief problematic following the death of the depth model and the rise of the field/context. How does the author get outside of the field in order to make sense of it? Where does the author go? *This is the question Greiman answers...*

Deeper in the Field

Quite literally. In 1986, Greiman, in what amounts to the first major exposure, or better, self-exposure, of her work, was asked to design issue Design Quarterly #133 for The Walker Art Center. She chose to present it as a single, six-foot, fold-out poster titled, 'Does it make sense?' To answer that question —if one can at all—one has to first tackle, head on, the most salient aspect of the poster, indeed the most shocking: a full-fledged, full-to-scale, naked woman whose eyes are closed, who possesses the stillness of deep sleep, or death. What have we exhumed here? Whose body are we looking at? Probably Greiman's? Maybe the objects buried with her provide clues: There is a male stick figure like you'd find painted on the wall of a cave, and just outside the grasp of his emphatically stretched stick-hand, a single-legged bird, or perhaps a flamingo. Hands extrude Shiva-like from arms: one makes a peace sign, another draws a circle, and yet another holds (could it be?) a wedge of cheese. Outside of our true-to-scale woman, there is an image of her face, her eyes alert, her smile wise and inviting; this is resting on the soles of her feet—a most unlikely place to find, the lettering above tells us, her 'spiritual double.' In the upper-left corner, just below a brain, there is a detail of her mouth, and on the bottom opposite corner, a duplicate in miniature of the entire poster. Beneath the body at the bottom of the poster, we discover a ruler. What does this ruler measure? The first three (of a total of 28) units are: 'proton,' 'neutron,' 'electron.' The fourth unit wants to be 'atom'— instead, we find 'moron.' Frustrated, amused, we pause. 'Proton,' 'Moron.' Greiman has sliced across the world of scientific sense to the world of poetic sense—rhyme—surprising the reader to aural pleasures. Indeed, the entire poster seems a joyous melange of worlds and senses, which begs us to resist the usual temptations: to frame it as either a formal exercise in expanding the use of image/symbol/text; or in politico-cultural terms, as the author's attempt to desexualize the feminine body. But how else should we frame this poster? Wait. There is writing. Some blocks of text are legible, others are printed upside-down, or miniaturized to the vanishing point. Sometimes the blocks of texts do what they typically do: indicate meanings, declare identities. At other times, we are not so sure what they do, if they do anything at all.

They seem to be bodies in their own right.

What aBody is

18

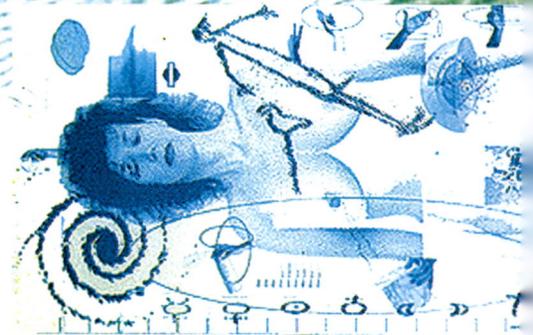

Two things.

First, precisely what Socrates took it for. A thing subject to uncertainty from outside, mischief from within. Bodies confound the objectivity of science, the equanimity of the law, the integrity of structures. Vulnerable to seduction, they trespass boundaries—others, and their own—and like ghosts, may even embody other bodies. If the mind is something dialectically spirited toward a pre-designated end, the body is something that is spirited by feeling and risk, by intuition toward the unknown, toward the constitution of what Husserl called, "vague essences." All things have a body; even words, symbols and signs, those stand-ins, utilities through which The Real is usually mediated. Where the mind has one unequivocal point of arrival, the truth, the body has provisionally many. And, unlike Aristotle who held that the trajectory of true bodies was a straight line, a teleological path outside the world of accident and chance, bodies of the type I'm speaking are engaged in accidental and chance encounters. We can see early signs of this in Marinetti's dizzying use of graphic language, the way words mingle with images in countless Dadaist works. When the body is set loose in the field anything can happen. For sure, the mind keeps the body in check, by assigning it roles, functions. But what happens when these bodies are freed of their roles or assignments? Have no intrinsic utility? Things which exist for the sake of..?

The second sense of the body: It is built-up, a construction, what Deleuze and Guattari call an "assemblage." It has the capacity to extend beyond itself, code with other bodies, it possesses what Nietzsche calls "plasticity." And because of this "plasticity," bodies can change scale, compromise structures, aggress, marry other bodies. In the poster to the left, the earth floats over a lunar horizon that is a kind of prosthetic for the cropped shin-bone of her leg. On the other shin we find a cirrus cloud, and at the intersection of her pubis? a dinosaur, and Stonehenge. A spiral galaxy romantically reaches into her hair and weaves into her.

A field, unlike a surface, is something occupied by bodies,

of which the human body, including one's own body, is only a single instance, just a participant.

The world is a field occupied by bodies, and every poster, as a field, is a world.

Cut-and-paste.

Cut-and-

paste.

Cut-and-paste. What joy. It saved the wheelchair-bound Matisse from madness. It freed, for him, colors from shapes, shapes from images, images from ideas. By cutting and pasting, bodies are freed from the stranglehold of context, designation, meaning. Greiman shares this joy, and takes it a step further. Her Mac is her scissors. This turns out to be much more than an articulate pair of knives. The capacity to zoom in and out, to isolate and frame and reframe and transpose and turn translucent is a technical advance that Matisse would surely have envied. In any case, let me not get carried away here

To get a better sense of what I mean by a field, let's look at Greiman's billboard/poster <small>Graphic Design in America</small>. In this piece, we are given a single thing, an American flag, that is composed of several images of the flag. In the far-left there is an old-fashioned parochial school image of the flag on a pole—the kind of flag we find at the head of countless military parades. It is a stand-in for an idea, for an idea we call 'America.' This is one of the realities of the flag. As the flag-image unfurls, its structure is released from the image-hold, and it undergoes a kind of transfiguration, so that the digitized stripes at the end quiver under a kind of pressure. It is as though we are witnessing an image becoming something awesome and energetic, like a wave breaking on a beach head. The flag seems to be happening as much as existing, or rather, it is happening and existing simultaneously.

To get a better sense of what I mean by a field, let's look at Greiman's bill board/ poster Graphic Design in America. In this piece, we are given a single thing, an American flag, that is

composed of several images of the flag. In the far-left there is an old-fashioned parochial school image of the flag on a pole – the kind of flag we find at the head of countless military

Cut-and
paste.

Cut-and paste.

Cut-and paste.

parades. It is a stand-in for an idea, for an idea we call 'America.' This is one of the realities of the flag. As the flag-image unfurls, its structure is released from the image

undergoes a kind of transfiguration, so that the digitized stripes at the end quiver under a kind of pressure. It is as though we are

witnessing an image becoming something awesome and

energetic, like a wave breaking on a beach head. The flag seems to be happen-

ing as much as existing, or rather, it is happening and existing simultaneously.

Graphic Design in America :

A Visual Language History

otograph
exploits that much of
A picture of the
for instance booming in Los
although
from the explore

this is the true flag, the

To Greiman, a photograph —the raw material that much of her work exploits—is a kind of frozen time. A picture of the atomic bomb mushrooming in Los Alamos, for instance, although several generations and hundreds of miles away from the explosion, still contains within it the 'cellular information' of everything that occurred since it's conception.

This jibes well with our recent knowledge of the genetic code, which I will use here as a heuristic to help us see what's going on with this poster. If we think of the pixel as the equivalent of the gene, we might rethink this flag-body in terms of pure information (I will use our knowledge of the gene not to prove my point, but rather to point to a parallel process.) Let's turn back to the flag with this perspective in mind. It is composed of 'information' bits of the flag, so that each moment of the flag contains within it the entire genetic information of the flag. These sections of information/moments are then isolated, and then layered. Which of these planes is the true flag, the true body? Or are we looking at a composite body, a new body put together from body-scraps? Though the latter explanation is visually justified, I would prefer for the moment to put it aside and try instead to think through the implication of what it means for bodies to be configurations of information bits. We know that each gene contains information for the composition of the entire body, and that each cell unfolds in a singular way based upon a distinct code. This is how a body unfolds and gets its parts. It is also possible that the gene possesses the cellular information of bodies past (could this be the 'junk' cells found by the Human Genome project?), and even information about the body's future, assuming there are distinct trajectories to the cell's development. Greiman's flag, then, is a body, or rather overlapping bodies composed of information bits. A body is dissolving, at homeostasis, increasing in complexity—all at the same time; phenotypes, potential bodies, unfolding from the genotypic structure of the cell. Now we can begin to think of multiple bodies, multiple essences, where we have usually thought of a single, static body. We can conceive the heavenly body/essence, the social body/essence, the historical body/essence, are all bodies/essences that are waiting to get bodies, just as light waits to get a body: a *particle or a wave body* (depending upon where we, as observers, stand in relation to it).

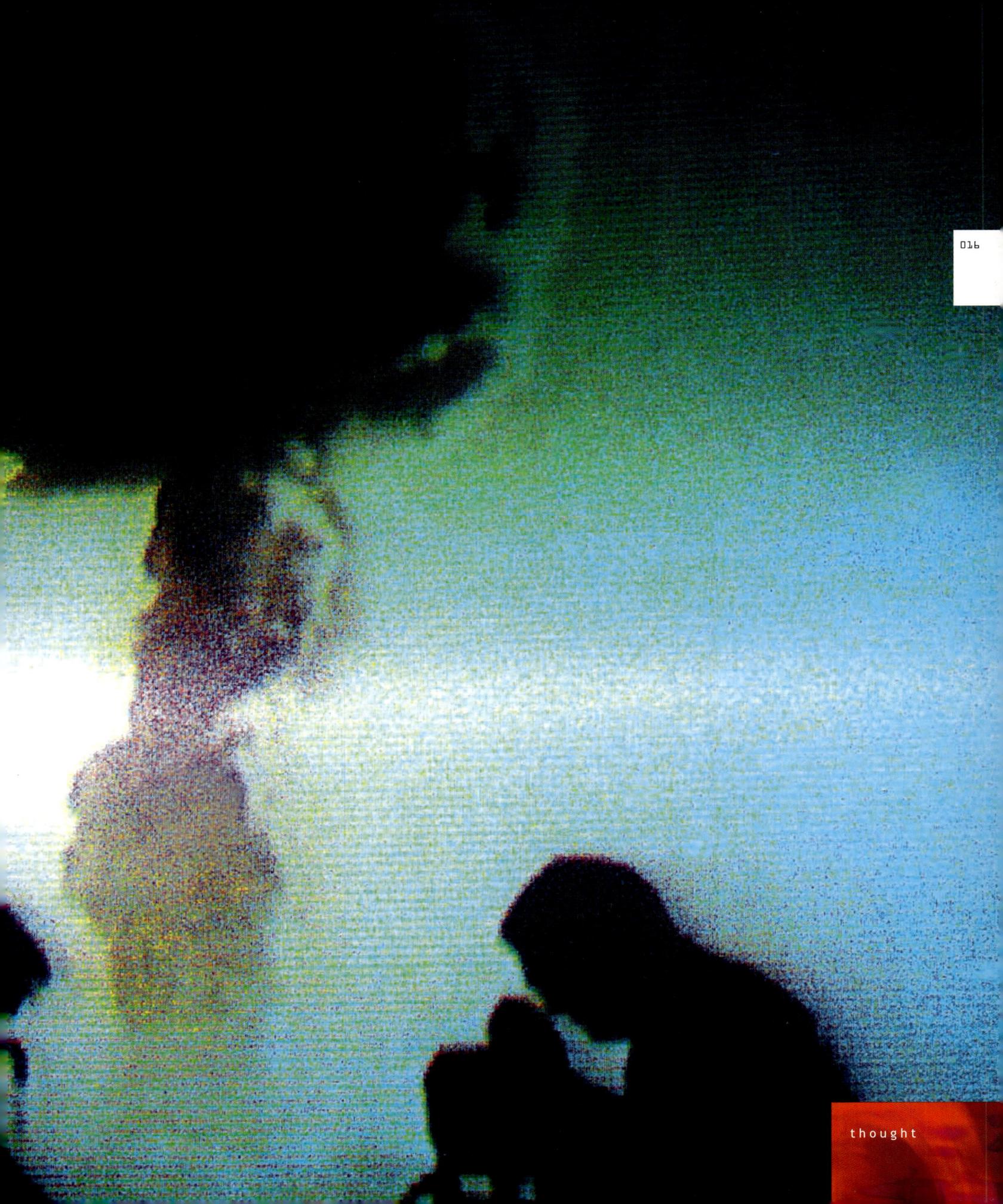

thought

Graphic

A Visual Langua

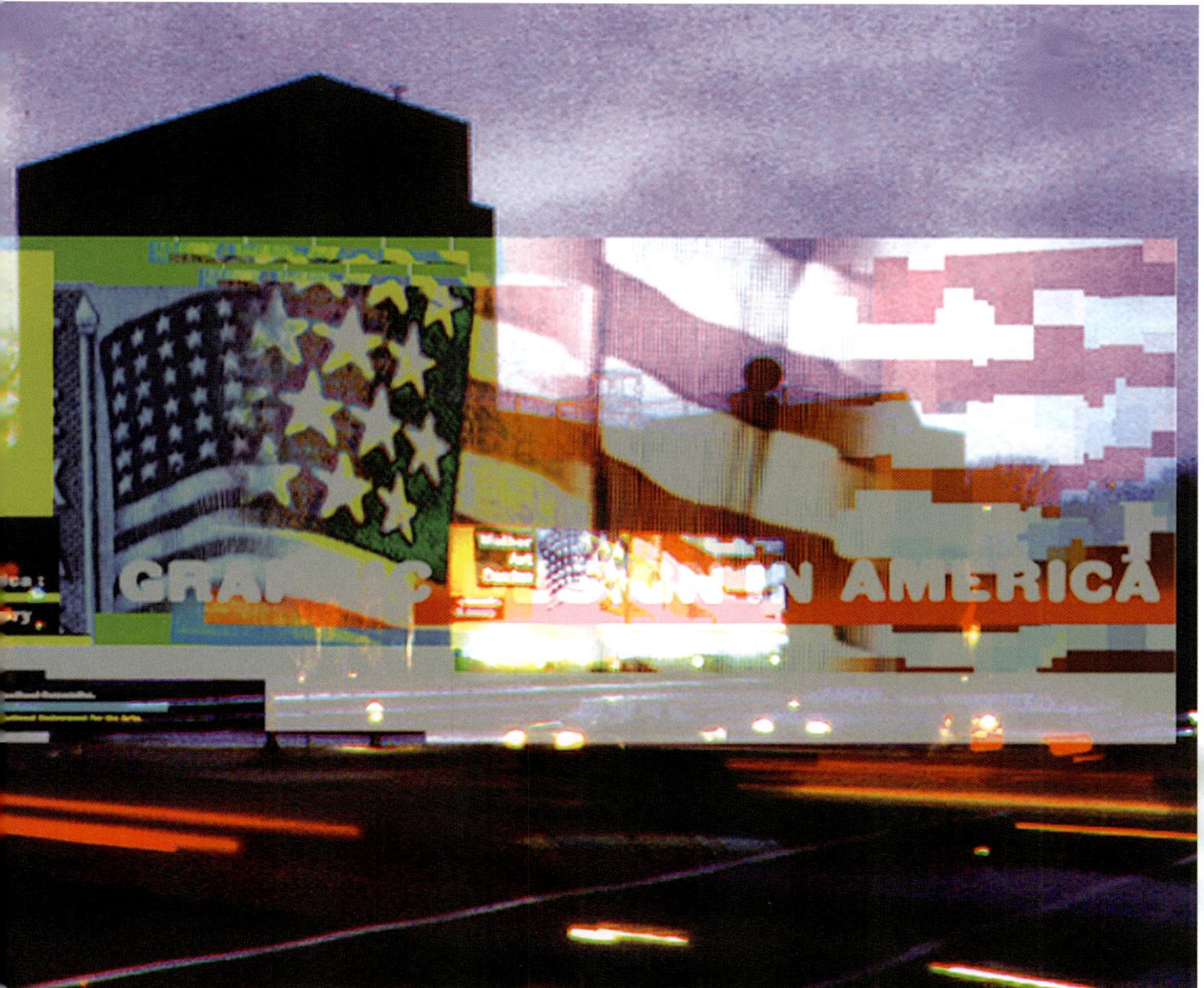

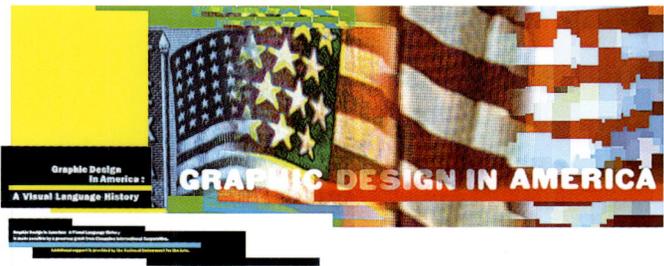

thought

PROG

32

Greiman takes a similar approach in her design for the 19th Amendment Commemorative Postage Stamp commissioned by the US Postal Service. But this work, done six years after the billboard/poster, goes several steps further. The themes of the 19th Amendment, made explicit on this stamp, are equality, freedom, and progress. There is a contradiction here, of course, since progress requires an inequality with the past. To say we have moved forward is to say we have superseded, moved beyond and ahead of... This problem results from a linear conception of time—or better, a diagonal conception, of time since progress also assumes climbing upward. The past, in this dialectic conception of time, is not only necessary to the present (which it requires for its forward movement), but also inferior to the present. The question then is: how does one both save the past for the present and from the present?

This question opens up upon a more general problem of time itself. Usually we think of time as points along a line, composed of standard and measurable units. Bergson shows that this kind of time, which dominates Western thinking, is endemic to a scientific world view that uses measuring instruments, like clocks or calendars, a view that possesses spatial bodies. It is a kind of structuring device, a scaffolding for the erection of homogenous knowledge. In contrast, the kind of time that the mind—a non-spatial body—knows is river-like, flowing, a heterogeneous succession of states that dissolve into each other to form an unbroken process. Bergson calls this "pure" or "real" time, which we access only by "intuition." History for Bergson, or indeed any structure, is the formalization of "real" time. Past, present, future—these are part of a dialectical system that segments and violates the flow of "pure time."

The Matter of Time

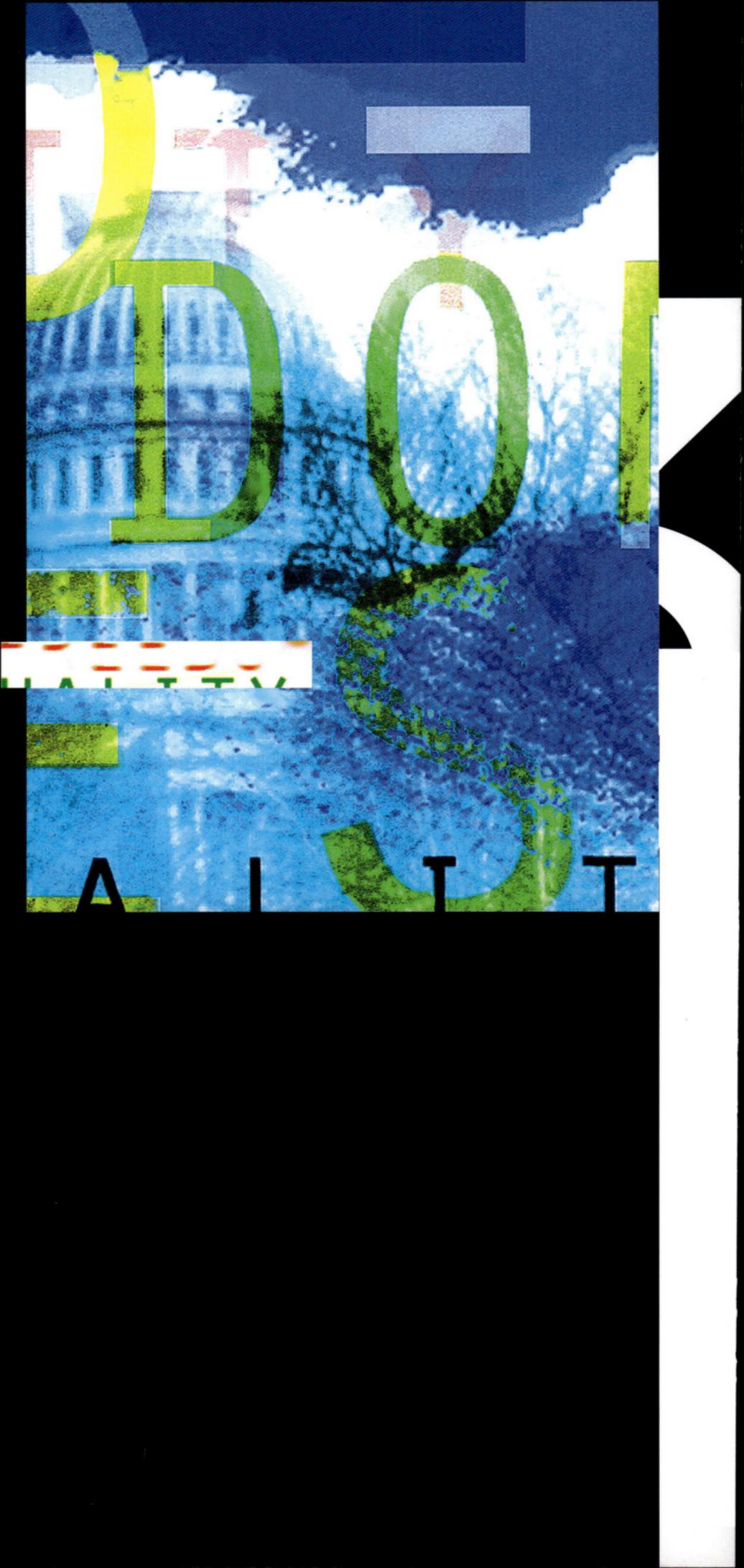

Her fold-out poster for Design Quarterly issue #133 already begins to address this problem. In that piece we find a virtual pictorial presentation of what the mind might look like in 'real time.' Stonehenge and a spiral galaxy, a pencil, a wedge of cheese: what are these if not bodies that exist side by side in 'heterogeneous' time? No attempt is made to stitch these bodies together with a narrative thread, which accounts for the challenge of the title: 'Does it make sense?' A different approach is taken with the billboard poster project. There the homogenous body of a single thing, a flag, is exploded into 'real time.' For the 19th Amendment Commemorative Postage Stamp, because Greiman is forced to recognize history, the problem becomes acute. The concepts of freedom, equality, and especially progress have no substance outside of certain historical reading of time. She must, then, be able to present two senses of time: real time, and historical time, that correspond to two senses of the body, non-spatial and spatial. Her technique is to 'layer' images; thin, nearly diaphanous shavings of

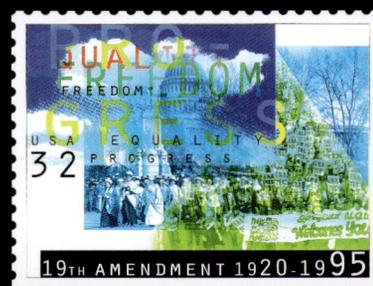

time-bodies—groups of freedom marchers from the turn of the century to the modern day, the Capitol Building, Supreme Court, trees, and clouds. Here time and space can be thought of, as they are by some in modern physical thinking, as occurring in a single dimension where the reality of a thing is composed of slices ('time-slices'). Even words get layered. Up to this project, Greiman still gives a certain primacy to texts. She is concerned, of course, about the right typeface, the position of the text and its scale in relation to the images, but she has not yet extended her conception of bodies to words. For instance, with the billboard poster Graphic Design in America, the script takes the linear format, with a typeface that runs where we might expect it to, along the bottom. Words at this point still possess a certain uprightness, invariability, their roles are sturdily guarded. But with the 19th Amendment Commemorative Postage Stamp project, letters change scale, and rise and drop like a mountain range. Even more radically, the words 'equality,' 'freedom,' and 'progress' appear in different hues and degrees of transparency as part of the images themselves. This has the effect of freeing the words, allowing them greater status than mere pointers to reality, the function they are typically assigned. They break away from their usual roles and take on bodies, in joining images they become extensible, spatially and temporally.

We get another sense of how Greiman rethinks time with her video clips for 'Lifetime TV.' In the one titled _{Joshua,} she gets to exploit a span of time itself—five seconds to be exact. We see a high desert landscape, caught (with an 8mm hand-held camera, it turns out, from out of a car) at a certain strange speed fast enough to blur but not so fast as to erase identity. The colors are marvelous, a wash of hallucinatory blues and browns and greens. From out of this landscape a bright orange box surfaces. This box turns out to be a monitor: boulders and rocks steadily pace against the grain of the more swiftly moving landscape, suggesting that we are now going backward, or perhaps sideways, in time, or in each direction simultaneously. Then inside the monitor, quite suddenly, the letter L, as though of some transubstantiation is born. The breathtaking lushness of this five second transformation means simply talking about it is beggared by comparison.

But if we are to add another layer to this body—the layer of interpretation that is—we must try. Bodies not only exist in time, they *happen* in time. Time is not something bodies traverse, but rather it is an attribute of bodies. By contrast, an Idea has no relationship to time, it is outside and impervious to time. An Idea is found, it is discovered, but it is not created, it does not happen. Yes, we speak of the 'progress' of ideas, or the 'evolution' of thought, but these are basically ways of speaking of holding spaces, kinds of purgatory until the Idea finally arrives. We should not mistake Greiman's approach with a kind of geological reading, always a backward-looking, excavating approach. For all of these time/speeds exist in potential—virtually in the body. We are not reading backwards, but releasing forwards 'time' that is frozen in these bodies. The ecstatic moment when the body breaks its own threshold is already present in the body. Everything is already with us.

Bodie

in time

snot onlyexist
; theyhappen
intime

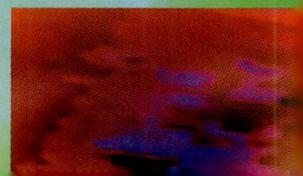

We think of color as decorative, what philosophers call a secondary quality, as opposed to the qualities of form and matter, that exhaust the essence of a thing. # Colors are given to bodies, but they do not possess bodies. A chair is a chair, red or green. The Fauves were the first to ask us to see colors as substantial bodies. Bodies of colors. Kandinsky made these bodies dance to music, freed colors from the hold of forms. He gave value to color's plastic, 'floating', variable existence. Likewise, for Greiman, it is the very variable existence of color that gives color power. From the Center: Design Process at SCI-Arc, a book that includes texts and images of faculty work at the progressive architectural school, is a showcase of what colors can do other than just color. White, the background, passive field against which words and images receive form, here

Bodies of Color

gets her equal share. No longer just a neutral surface upon which the writing is inscribed, or images put, she is rather a physical force, a body that responds to other bodies in an environment. White hugs, and curves around images. It provides a scaffolding for texts. Sometimes white jumps into the spotlight. It becomes the color of text, against a black background, like chalk on an old-fashioned blackboard (SCI-Arc is, after all, a school). All the colors in this book serve outrageous purposes. They become nesting places for texts, virtual breeding grounds. Orange becomes the medium for the articulation of a line-drawing. Colors collide, express tensions, extend the significance of images. They can give porosity to a text, or enclose a text in a kind of organic wrapper.

Aside from the play of colors, the question Greiman poses for herself with From the Center: Design Process at SCI-Arc is: can a page approximate the nature of the three-dimensional world?

Can a page approach architecture?

The answer to this question appears in her radical treatment of texts. Already, from the 19th Amendment Commemorative Postage Stamp project on, it is hard to keep Greiman's typefaces in place. They seem to possess a kind of eagerness to play multiple roles, to dance, to be part of, as well as to much signage pointing to the action. But with From the Center: Design Process at SCI-Arc texts respond, form a kind of intimate circuit with the images. Sometimes they copy, sometimes they hollow out in precisely the shape of the architectural image they refer to. Sometimes they seem to simply generate from out of themselves their own structure giving a whole new sense to a 'column' of text. All in all, there seems to be an exchange of information between color, text, and image. The same way, for instance, a bee and a flower form an empathic circuit.

How can we allow a door through which the observer might pass into the field, not just mentally but sensually, physically?

How do we create an environment in, for, play?

jugando,

para,

jugar ?

S C I — ARC

Southern California Institute of Architecture

Michael Rotondi	310 574 1123	5454
Director	Fax	Beethoven Street
	310 574 3801	Los Angeles
		California USA
		90066

the macro to the micro

¿Cómo creamos un ambiente

the dna of the computer

Southern California Institute o

S C I

Southern California I

sci A

sci AR

chitecture

ute of Architecture

¿Cómo podríamos crear una puerta por donde el observador atravieza, no sólo, mentalmente, pero también sensualmente, físicamente? ¿Cómo crea

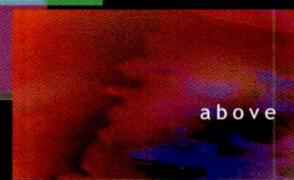

S C I A R c

S C I R c
Southern Ca

above

In thinking about this, I laid my eyes upon a photograph out of Greiman's collection, one of thousands she's shot on her nature pilgrimages. The only information we have about this photograph is when, not where, it was taken. The digital read-out on the left margin says July 9, 1993. The photo shows a red stone structure that rises to fill the sky, like a gigantic tidal wave arrested in space. Near the crest the wave shows a giant hole into which light pours from the other side. Centuries of water must have flooded through to form the penumbra around the hole. The only sense of the scale of this fabulous structure is given by Greiman's figure, a mere ant, on the canyon floor below.

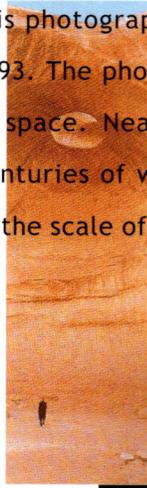

¡yo!

Natural Circuits

How to approach the physical earth, the natural world, is one of the thorniest issues that face serious artists, and I think this picture, in some ways, answers it for Greiman. But first, what has happened to the natural world in the artistic world? Artists like Smithson or Christo or Hockney have approached the landscapes or the natural environment in novel ways, for sure, and I have seen a spate of room-size installations that attempt to simulate natural environments for some conceptual purpose. But for the most part, the absence of the natural world from contemporary concerns is really quite astonishing. In perusing a recent Taschen book titled *Art of the Millennium,* out of 137 artists hardly two or three directly worried themselves with the natural world. Given that we are so obviously and intimately connected to the physical world, precisely why this is the case is difficult to sort out. Clearly our relationship to the earth has become much less direct over the past two hundred years. Today, even if we can easily traverse the globe, we still catch nature through the controlled frame of pathways and gates and signs, or an I-Max camera or the like. It seems as though it has become in our mind's eye—the way that the perspective we are allowed is always set up in advance of us—a picture of a picture, a confirmation rather than an encounter. In the same vein, perhaps when we view the earth we are almost hopelessly forced to do so through a Romantic frame of associations. Love on the beach, solitude in the desert, transcendence in the mountains. The earth then has become, on the one hand, monumental, something we respect too much to approach, or on the other hand, anachronistic, approachable only by way of old and soapy tropes.

For the Romantics, nature was thought of as the 'Other,' of human existence. Burke saw it as that which extended beyond the realm of conceptualization, that which exploded the mind just as it was about to seize it. One always risks missing a few chance artists or shows in making such a general statement, but I think it would be fair to state that art these days is primarily devised to get people thinking or reflecting about society, the status of art, the status of art as a reflection of the status of the world, etc. And to be fair to the troubles of these artists, we must allow that, à la Fredric Jameson, the very alienated social world of late capitalism may just be for us what nature was to the Romantics: that is, the Other is ourselves.

But there is a way to understand our relationship to nature that conceives of it as neither beyond nor superseded nor gone. To understand this let's briefly return to the old-fashioned landscape. Its primary concern is sensuous, to physically subsume the viewer, or better, to allow the viewer's body/mind a coupling—violent, serene, etc.—with nature. The convention of placing a person, a barn, or a cow, or even a ship in the painting is intended to invite bodies into the experience. Looking from a mountain peak down upon a great valley, we know the inner silence of our own bodies, or the vertigo of our own physical boundlessness. Nature is not the 'Other,' but rather nature is in us as much as we are in nature. Who better expressed this than Leonardo da Vinci? 'The Virgin of the Rocks' is a painting steeped with mystery—so it has been said over and over again. This work has been crisscrossed with symbolic interpretation in an attempt to finally unlock its 'meaning.' But there is another layer to this work that is closer to my own interests. St. Anne, baby Jesus, and the Virgin, all sit at the edge of a pool of water. Little John the Baptist extends himself like a spray from the plant beneath him; the baby Jesus is in the embrace of plants, one flower blooms right out from his groin. Not only do the plants reach out for the characters, but the characters seem imbued with a kind of heliotropism themselves when they reach out to each other. The boundaries blur (with sfumato), and structures of plant, human, water, and rock fuse into a single, shared 'empathic' circuit. To exploit the jargon of Deleuze and Guattari, we are "becoming-nature," just as nature is "becoming-human." This painting gives us a window onto a particular kind of encounter with nature—an intimate one. From this perspective, the Otherness of nature, the Otherness of others, is the result of a certain reserve our own natures' possess in relationship to it.

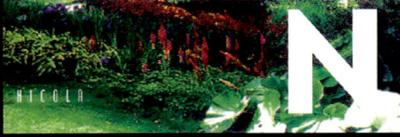

Californians are easily seduced out of this reserve. In 1911, George Santanyana rightly observed, "I am struck in California by the deep and almost religious affection which people have for nature and by the sensitiveness they show for its influence... It is their spontaneous substitute for articulate art and articulate religion."[3] Inside of two hours from Los Angeles alone, you can loaf on the beach, drown in the desert, climb with mountains, swim in a lake. The ejaculations 'I get it,' or 'I don't get it,' so common to idea-art, are not germane to the experience of melting into the Yosemite Valley during a hike. You may 'get' a landscape, but it is equally likely, in California, that a landscape will get you.

I go to such lengths about landscape and nature, because it is a major aspect of Greiman's work. Clouds, horizons, mountains, beaches, desert, boulders, rocks, flowers and plants, pools of water—everywhere in Greiman's work you find an eager reception of nature. Her graphic work for Nicola Restaurant, especially for the billboard, is a fertile place to start. Grass, ground cover, foxgloves and sashes of red flowers give this piece a quiet richness. In the lower-left of the garden are the letters N I C O L A. The letters spring from the grass like white poppies. Tucked in the right-hand corner is some tropical plant with broad leaves whose slick skin reflects a strong, crisp white light. As does the letter N, as it must, since it has grown up—I am inclined to say—in that garden, as if has taken on a kind of plant-like existence. Outside of being a plant itself, the N has another job to do: it is a passageway for us, a gate, where we might —more, just—plant ourselves if we care to enter into the garden. Greiman has invited us into a physical, not merely visual experience of this garden this way.

Her print material for Coop Himmelblau, an architectural firm responsible for aggressive articulations of architectural space, gives us another example of Greiman's treatment of nature. What immediately strikes one about the letterhead its desert-like austerity, how its near emptiness floods the eye. At the bottom of the letterhead is an impossible horizon made of a soft, spill-of-milk cloud layer, visible from nowhere on earth but conceivably from several hundred feet in the air. The sharp, steely horizon line itself echoes the black and white rectangles (inside of which the details of the firm are given) that move stepwise from left to right at the bottom of the page. At the top of the page the same kind of industrial-like boxes receive the firm's logo, and below it are given the principals' names. The middle of the page—except for an almost ephemerally faint margin, a line thin as floss that strings out across the page, stops, and resumes a fraction of an inch higher up—Greiman leaves

empty. The effect is heady:

Everything seems to float. We feel as though we are about to step into a territory of exquisite breadth and silence. The visual trope of expansiveness introduces an opening for the body of writing –typefaces, handwriting, scribbles, doodles, etc. What walks into this blank atmosphere is writing, landscape receives the body of the text.

Around this time, I believe that Greiman makes a leap from thinking of the page as a field to configuring it as an environment. By environment I mean a setting where things exist in some kind of affective relationship, as opposed to the merely mental/ meaning relationship that one gets in a field. But more importantly, the idea of environment makes room for the body of the viewer. It invites the viewer into the work, as do landscapes. And with that move, the environment is perhaps more than a set of relations, but a place *for encounters.*

B (L) A U

CULVER CITY CAL
8561 HIGUERA STREET
SEILERSTÄTTE 16/11a
A-1

USA

A 90232 FAX 310 | 838 8267
ENNA 01 512 0284·0 FAX 01 513 47 54 · 21

310 838 8384 FAX 310 838 8287

AUSTRIA

01

and

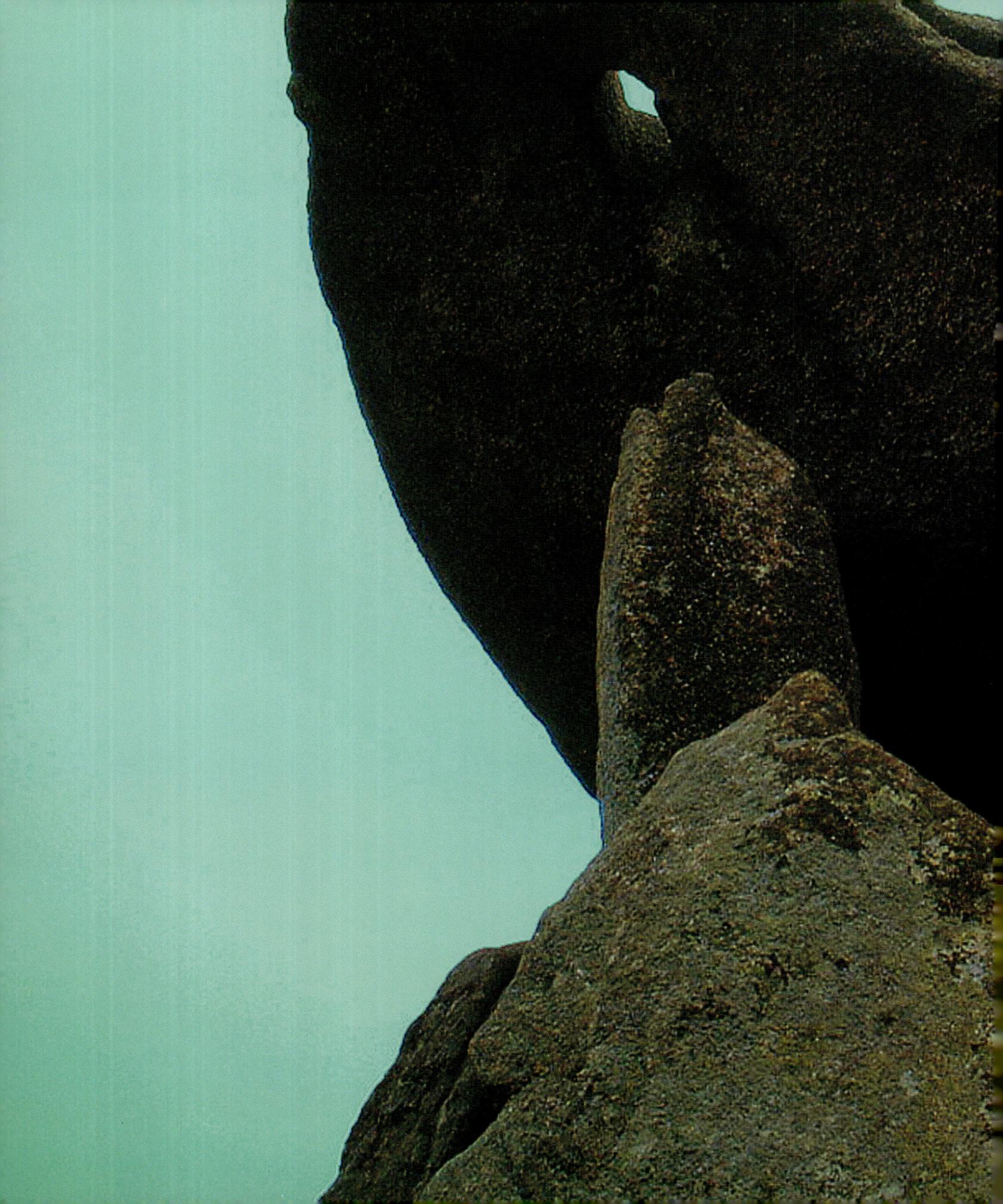

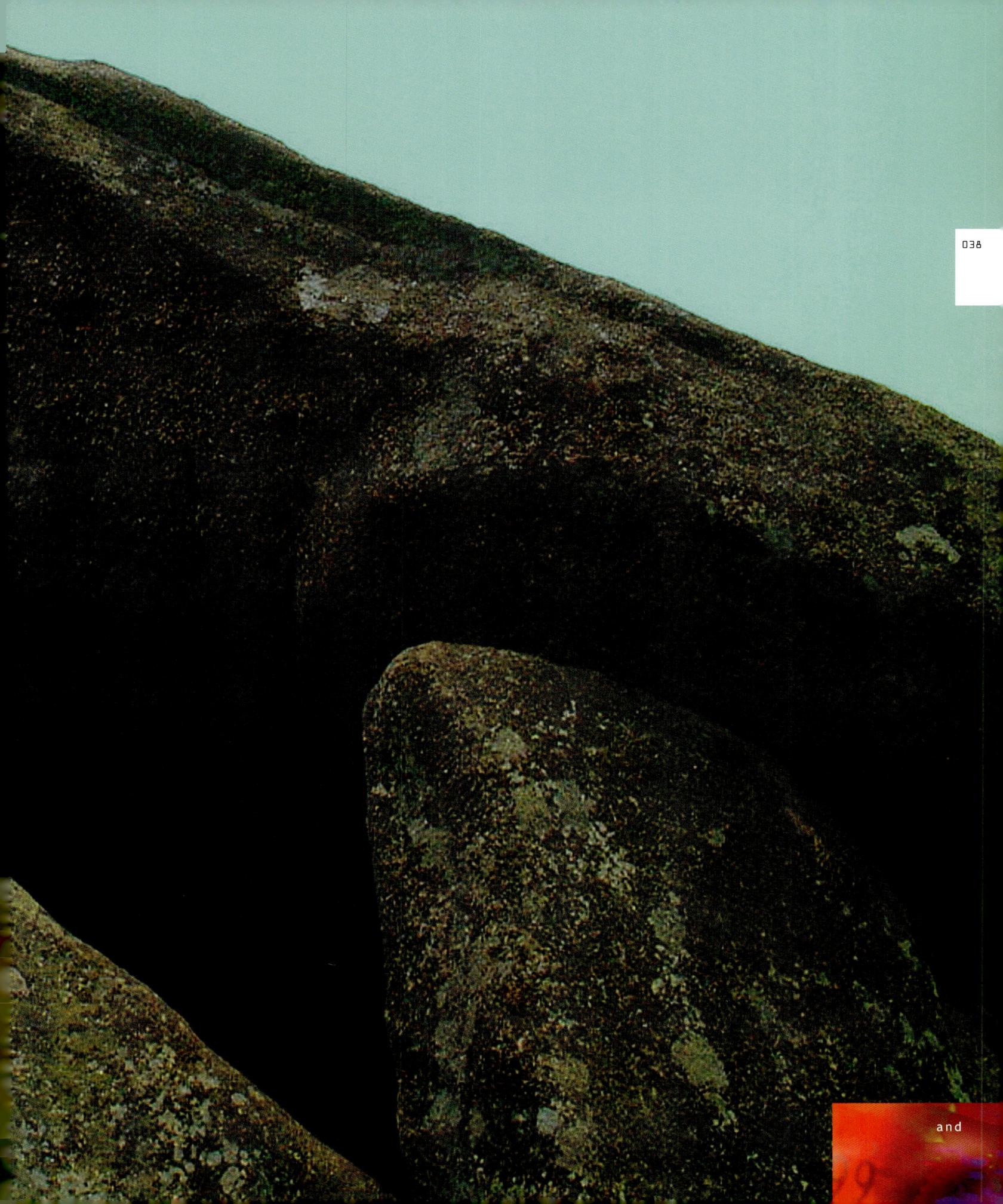

and

The Function of

Now, let us return to the picture I described above of the hole in the stone wave. There are at least four senses to the hole. The first sense is theological. Here the rock-body signifies the absence of a finished project, the second coming, an Idea planted from the beginnings of time waiting to complete itself. We are in awe and estranged from it at the same time. Second, corresponding to an Enlightenment or Existentialist sense, the hole is an opening, a passage that allows us to transcend and retain our human integrity against the otherwise crushing monumentality of the rock-body. There is no Other to existence upon whom we are waiting, but rather we are faced with filling the hole with the reality we conceive. The third sense of the hole, corresponding to a Derridean reading, is that its absence is necessary to the structure of the monument: it is the very presence of the hole as absence that keeps the project of completion or transcendence open, never-ending. The whole needs the hole. And the final sense: the hole is waiting to be filled, but by something alien to it. Wind fills it, water and sun fill it. But also, with the courage of water or wind or sun, so could we, with our own bodies. It is only this last move that would unlock the wave from its stone-hold and turn it into a fantastic and violent movement creating and crossing its own threshold. The degree to which you are willing to risk an encounter with the natural world seems to be at issue here. I guess what I'm talking about is a return to the sublime. But here the sublime is not the ultimate crushing Other God's body, which no man could lay eyes on and live, but that which we experience when we encounter a structure seemingly 'alien' to our own.

O

There is also an O, in her work for R o T o A r c h i t e c t s .

This project involved print material for the architectural firm whose work is as close as one can get to a spiritual union of form

and material and program (only because it is suggestive do I mention that one of the principals of the firm, Michael Rotondi,

is her lover.) We are on a rooftop; the vents look like bushes, outcropping on a mostly barren desert-like industrial landscape.

Situated on the right side of the card is a billboard-size O. In fact, it is a billboard. Well, nearly. It is supported by beams,

but the beams are secured to the air. Go figure. The O hangs, in this anomalous floating state, irresistible. We can think

of it, metaphorically, how it stands in for every thought that is at once complete and incomplete. We hollow our lungs

when we say it; we mirror its shape with our lips (red) when we kiss. We could have it frame the jungle LA world

out there. But mostly, we could step into that 'O' and lose ourselves, like Alice did when she stepped

into the Looking Glass.

99

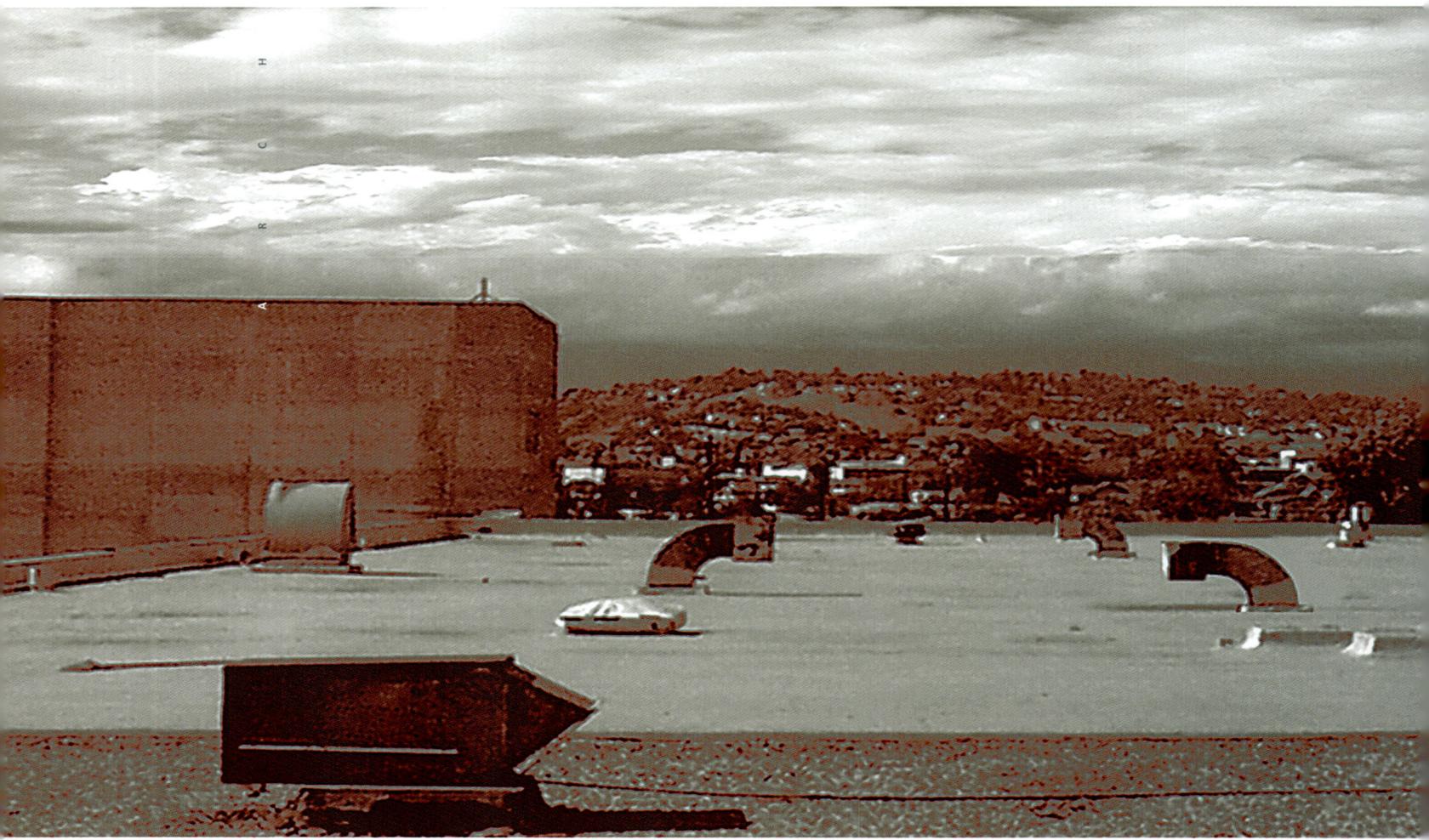

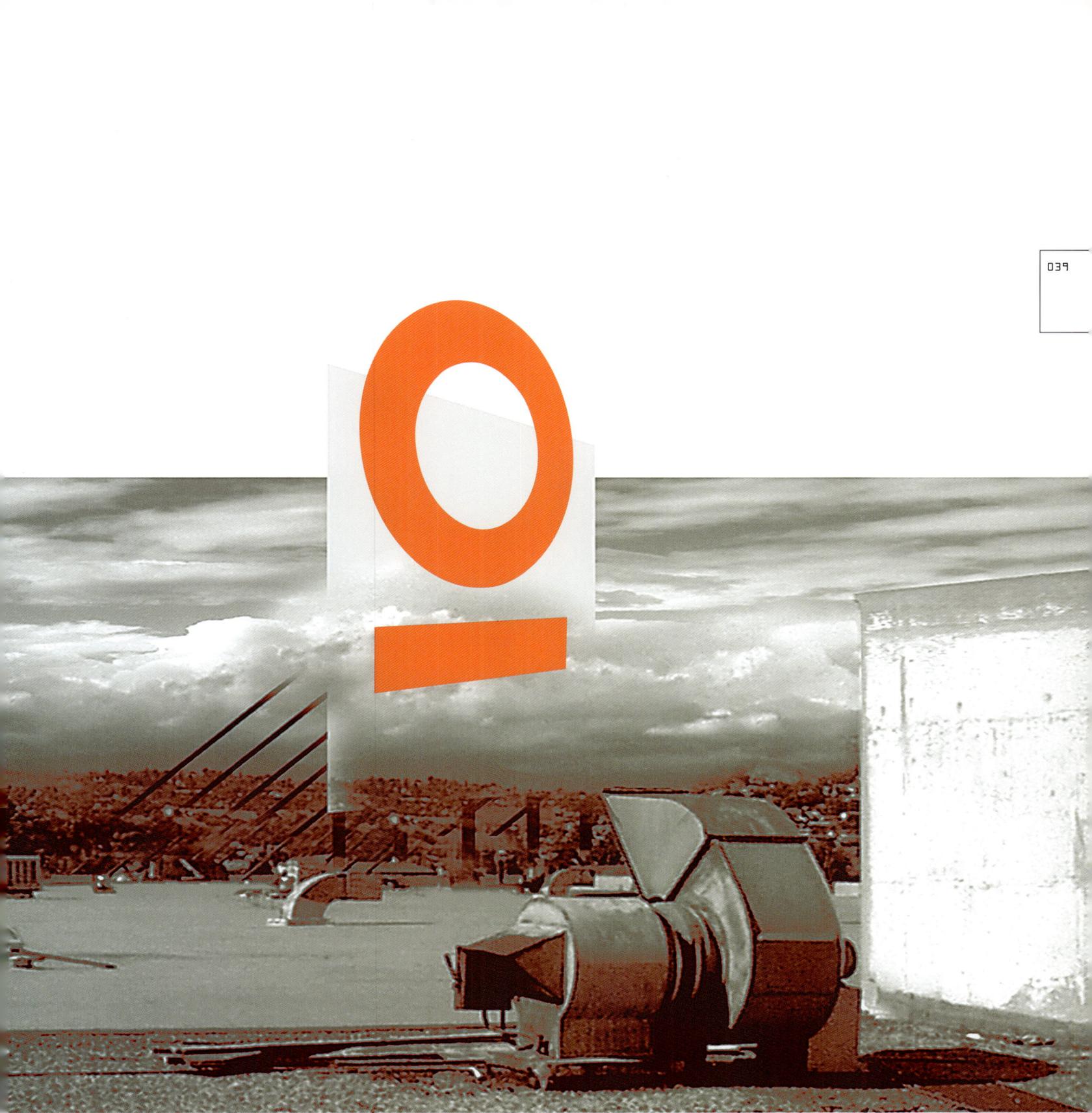

fax 323 **226 1105**
323 **2261112**
roto@rotoark.com

A R C H I T E C T S INC

RoTo Architects Inc.
600
Moulton Avenue
405
Los Angeles
California
90031

600
Moulton Avenue
405
Los Angeles
California
90031

R O

ARCHITECTS

] INC

IT HANGS
AND IT FLOATS

TO

STEP INTO

A VOID

above nature and above time and above thought

above nature and above time and above thought

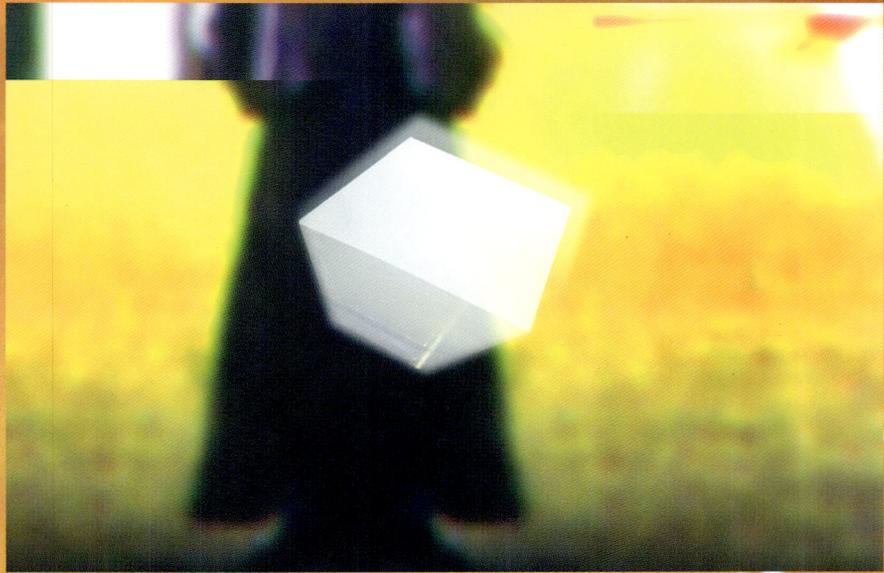

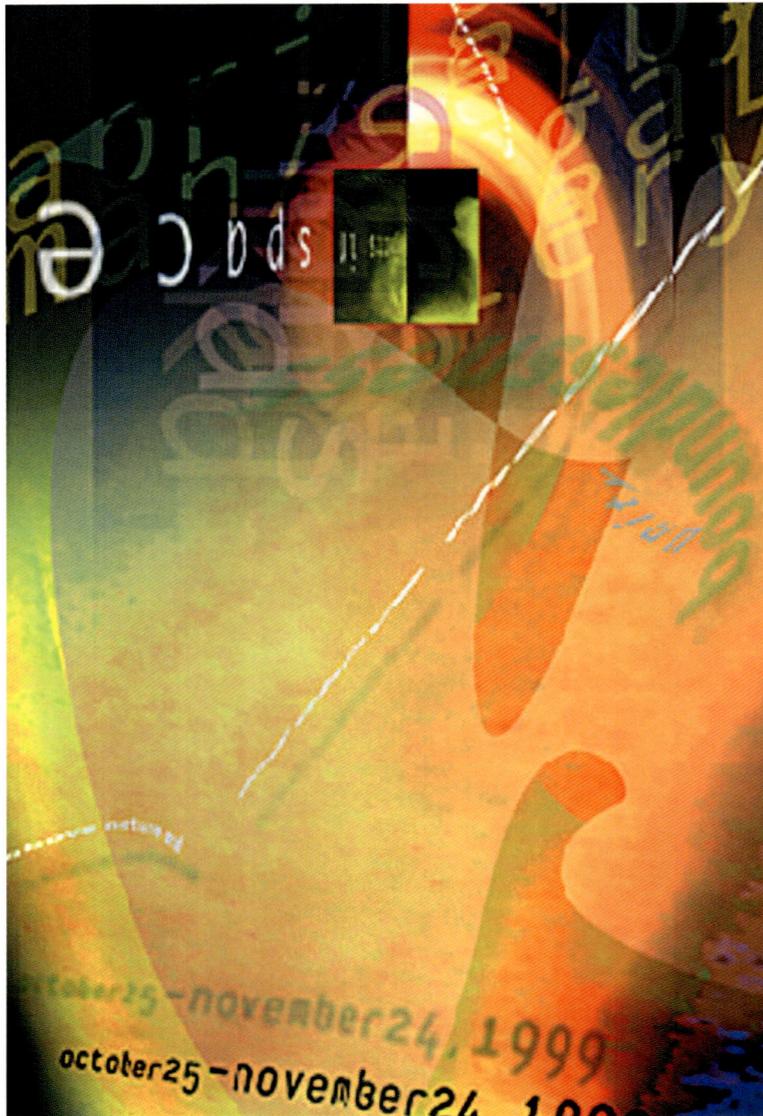

64

Atmosphere

Greiman's prints with a piece she produced for an exhibition of her work at the Ringling School of Art and Design's Selby Gallery; a work I'd like to call her Masterpiece-to-date. This piece adds an extra dimension to our discussion so far. I would call this extra dimension 'atmosphere.' We have seen how Greiman's work has moved from surface to field, from field to environment. The characteristics, once again, of a graphic design environment is that each of its components; text, image, color, and even the viewer, are non-hierarchically arranged, free to play multiple roles, exchange genetic information, and form through a kind of plasticity and affinity, a circuit with each other. With each move Greiman's work has acquired a greater and greater degree of richness, as a result, I think, of her increasing acknowledgment of the richness of The Real.

Sometimes environments produce atmosphere. In natural environments the quality of air and light and shade and tone and mood produce atmosphere, but these qualities are also present in 'artificial' environments as well. To tell the truth, the presence of atmosphere is difficult to describe, but not difficult to know. Anyone who happens out of a thick forest of trees upon a glade, or enters the courtyard of the Salk Institute, or up the worn stone steps of a medieval cathedral towards a prayer tower, or listens to Glen Gould playing the Goldberg Variations at dawn on a summer day, knows what I am talking about. Atmosphere is not, as the Post-structuralist critics would have us believe, artificial; it is not a magical and supplementary dimension added to an environment. Atmosphere is a dimension of the Real. The sense we have when entering an environment with atmosphere is one of being lifted up into or enveloped by (): recognizing an intimate correspondence between something Other and our own natures.

Now to the Selby Gallery Poster. It is as tall as an average man, and about a yard wide. The first impression I had of this piece was of a sunrise over a landscape. Warm yellow floods up from the bottom and bleeds into fiery oranges and reds and greens and purples and deep blues. But unlike a sunrise, where these prismatic colors appear on the horizon, we seem here to be looking down and through these colors onto a variegated landscape in part marbled or rippled or mottled, textured in as many and unexpected ways as a sand desert is textured by wind. The piece, lusciously bathed with light, approaches the effect of an oil painting executed with glaze over glaze over glaze that sets off the *impasto* of the highlights—here, the texts. The latter, like clouds build to presence, hover, stretch to the point of shredding, and evaporate. And everywhere the letters of these texts fall out from their assignments, as though tired of the pressure of staying put, and go at it alone in a precarious and fading moment of anonymous and bodily glory. In this strangely closed yet infinitely rich world, all the texts seem to stream from out of a bisected box nested in a spiral of fire located in the upper center of the poster. This box, whose hard geometry is striking against the luxurious and organic forms that free-float around it, seems the matrix of energy for the entire poster. From the right half of the box the text OBJECTS IN SPACE, precisely like a string of sky writing, streams out upside-down. Another gossamer line of text, reads "above nature, above time, above thought." What does it mean "above?" This is, I would suggest, a manner of speech that points to what I have already described as the richness of the Real, or more precisely those dimensions of The Real of which one knows but cannot discursively speak.

thought

thought

I must apologize if I've done too much too fast. The way to properly prepare the ground for a reading of Greiman's work would require I lay a thick layer of philosophy over it. But that would have also burdened the filmic images of this book with which this essay is hoping to synchronize. So I've tried what may be impossible: to give weightiness and lightness to the text at the same time. With that said, I would like to do just what I eschewed earlier: spend some time philosophizing about what I have on and off again called, in the course of this essay, The Real.

In the West, we have divided The Real into two possible frames of reference, or perspectives. The first perspective, that taken by all practitioners of science, professional or naïve, is that the Real is out there waiting to be discovered, and that the laws that govern it are uniform across space and time. The person's role is as neutral observer. Whether one holds this or that opinion, or is bitter or joyful, has no bearing on The Real, except as it mitigates one's ability to observe dispassionately. In this context, our conceits, our very selves become 'noise,' or a source of 'error' in these observations. The person is a non-participant in The Real.

70

The second perspective, usually called 'Subjectivism,' holds that whatever we might know of The Real is not out there but rather in us. There is no way to get to The Real other than through our own conceits, so much so that the world is nothing other than a projection of these conceits. In other words, whatever we see, we see through a particular color lens. These lenses are, to some, the source of human creativity, and to others as regrettable as they are an unavoidable source of arbitrariness and confusion in regards to judgments of The Real. Whenever we look at The Real, in actuality we are only looking at ourselves. This has the effect of liberating us from the demands of The Real. We are free now to construct the world as we like.

There have been adjustments to these two perspectives which I am obliged to bring up at this point. The first is the Structuralist perspective, which in modern times Kant initiates, and continues to underlie the perspectives of philosophers as diverse as Wittgenstein, Piaget, Chomsky, Foucault, and Derrida. It holds that The Real, as we know it, is the result of structures—psychological, linguistic, physiological, to name a few. These deeply embedded structures allow for humans to negotiate with the world in an adaptive way, but at the same time they limit what it is possible to experience and know, as well as attenuating subjectivity. Structuralists proper, and Post-structuralists, primarily differ on how they view the susceptibility of these structures to change through human agency. The first group argues that these structures are 'hard-wired,' innate as say, the color of one's eyes, and thus are hardly susceptible to change, except, perhaps through thousands of years of genetic or social evolution. The second group, the Post-structuralists—argue that these structures are 'soft-wired,' socially constructed, and thus are somewhat mutable. For instance, as regards language, Chomsky believes that the mechanisms which account for the acquisition and syntactical organization of language occur as a result of psycho/biological structures. Deleuze and Guattari, on the other hand, have argued that the "the unity of language is fundamentally political,"[4] where a bellicose dominant, or major language always attempts to seize and control a 'minor' language.

Whether some aspect of The Real resides on the other side of these structurally mediated encounters is debatable. For Structuralists, the answers seems to be 'no.' But for Post-structuralists, the answer is a tentative 'yes.' How do we make contact with this reality-on-the-other-side? the responses vary, but it is generally held that it involves a luminous, sudden, and violent break with the usual way of knowing. Foucault called this break "transgression." For him, though, The Real was not something out-there one contacted, but rather the empty space inside of oneself, hollowed of every device to order the world, where one knows, however briefly, the "immediacy of being."[5]

I do not believe that either the Structuralist or Post-structuralist perspective changes the fundamental relation to The Real that we get in the simple version of Subjectivism. All three of these perspectives advance from, and stop at the boundaries of the human, well short of the world-out-there. With Subjectivism, the conceits which constrain our relations to The Real are variable and personal (e.g. mood, upbringing), while with Structuralism and Post-structuralism these conceits are largely invariable and cultural. In either case, we close in ever-tightening circles around our own selves/humanity/anthropology, while other dimensions of The Real are left unrealized.

The second adjustment to the two standard perspectives is the dialectic. Hegel and Marx and their respective heirs are the modern promulgators of this point of view, which has the world-out-there and the world-within-us caught up with each other in a simultaneous transformation. The Real, here, is waiting to reveal itself, but it can do so only so after passing through a series of confrontations between opposite forces. The dialectic assumes a purifying end point to this confrontation, though what that end point looks like hardly anyone has the gumption to say. This perspective is seductive, which is why since the advent of the Modern period it has shown a remarkable capacity to resurrect itself even after being buried over and over again. It emphasizes movement over stasis, it destabilizes hierarchies, and it recognizes a goal. But the dark side to the dialect is that it undermines the integrity of bodies, reduces them to a mere slaves in a movement governed by some master plan. The Real is deferred until the dialectic is complete. We suffer purgatory until the final day of reckoning.

I have tried to be consistent in calling these philosophies 'perspectives.' I borrow the term from Nietzsche's vocabulary, in particular to his "perspectivism," a construct I briefly want to turn to now. Nietzsche is widely recognized as the godfather of Post-structuralist thinking. He has been hailed for ushering in an age where all of our certainty as regards ourselves is reducible to an underlying "Will To Power." Where our certainty of the external world-out-there is concerned, Nietzsche had mixed opinions. At times, he seems to think that science is the only safeguard against the prejudices of the "self." At other times, he ridicules science for its so-called "objectivity," its presumption to vanquish human subjectivity from the scene of observation. The "perspectivism" of his more 'mature' writing seems, on the surface, to support elevating subjectivity while downgrading the objectivity of science.

thought

But I've been speaking of "perspectivism" as though its meaning was obvious. Let me try to flesh the idea out. In *On The Genealogy of Morals* Nietzsche asserts, "there is only perspective seeing, only a perspective knowing,"[b] by which he means our approach to the world is conditioned by a complicated mix of our physiology, temperament, geographical location, cultural value system, and the broader value system of our epoch. All of these factors create a template for the way we render the world, so much so that "the essential feature [of our thought] is fitting new material into old schema... making equal what is new."[7] Nothing about us, then, warrants our pretension to a balanced, much less 'objective' point of view. Moreover, our very striving for 'truth' or 'knowledge,' that which we usually equate with a spiritual quest, is rooted for Nietzsche in a nearly physiological reflex to envelop, or subsume into our own natures the world: "the entire apparatus of knowledge is an apparatus for abstraction and simplification—directed not at knowledge but at taking possession of things."[8] His Post-structuralist heirs, Bataille, Derrida, Foucault, believe that Nietzsche's critique places our understanding of the human world, as we'd known it since classical Greece, in jeopardy. We can no longer be confident that our speculations and theories about ourselves, society, or even the stars, amount to anything more than elaborate fictions. From this perspective, the goal is not to 'further' knowledge, but to reveal the mechanisms, the means we use to order the world.

I find this perspective depressing. Not because it robs us of progress (who cares about progress when there is so much to encounter?), but because it debases the world out there. If we are mired in our own devices the world flattens, and grows impoverished as a result. But more importantly than what I feel, my surmise is that the Post-structuralists' reading of Nietzsche is half-hearted, not daring enough, still rooted in a reaction to the depth model. Most of the quotes I've cited above are from a single paragraph from Nietzsche's masterpiece *On The Genealogy of Morals*. Near the end of that passage, Nietzsche asserts something quite remarkable and, I believe, at odds with the usual Post-structuralist interpretation:

"...the more affects we allow to speak about one thing, the more eyes, different eyes, we can use to observe things, the more complete will our 'concept' of this thing, our 'objectivity' be."[9]

h this despair over our own depthlessness—what he called "nihilism." I believe the
that Nietzsche sensed that the world beyond depth did not flatten, or impoverish the
ned us up to richness. Richness versus depth.

I also believe Nietzsche anticipates recent theoretical developments in
nformation science, physics, psychology, biology, and even architecture about the nature
developments point, using different vocabularies to be sure, to the idea of The Real as a
information, out of which bodies emerge, or take form before melting back into that
pective drastically differs from those I have enumerated above. It denies neither the
bject, the observer nor the-world-out-there, indeed, it denies that the two are separate at
erspective, which has its intellectual genesis in quantum mechanics and quantum physics,
 object as part of the same order, what physicist David Bohm calls, "The Implicate Order."
ne, the implicate order is part of a multidimensional, perhaps infinitely dimensional reality.
ive, what we draw out of that reality, is the *explicate order*. The Real is not found, it is, as I
this essay, waiting to 'happen,' an infinity of virtual worlds, folded inside an implicate order.

thought

What the role of the subject is in this reality is difficult to pin down. Like Nietzsche, Bohm believes that we tend to mistake our rendering of The Real from a particular perspective for a complete picture of reality. Most of the time the subject acts as a machine for stamping out reality time and again from the same mold, resulting in re-recognition at the level of perception, and repetition at the level of the world. For Bohm, intelligence, the true seat of creativity, is the human attribute that allows us to disengage from this machine-like role and make jumps from one dimension of reality to the other, 'intuiting' along the way the implicate order underlying our explication of the world. The only other way we could know the implicate order, or what I have called The Real, is to occupy every possible dimension of reality at once.

The latter approach brings us up to the borders of God. He who is capable of seeing all of reality, every facet of it; all knowing (Omniscient) because He is simultaneously everywhere (Omnipresent), or, in other words, outside the constraints of space and time. The human subject, I would argue on the other hand, is only able to be at one place at a time in relation to The Real. We are not capable of taking a perspective outside of space and time, what is required if we are to know the totality of The Real. Moreover, each perspective we take 'forfeits,' all other perspectives. Once we occupy a place vis-à-vis The Real, we close the shutters on every other vantage point. (Time itself just might be the duration of our occupation of a perspective). This does not mean, however, that we are stuck in that place. We can change perspectives vis-à-vis The Real. What makes us human is just this capacity, what Nietzsche called "plasticity."

ooking

or a body

Earlier I said that in the context of a scientific experiment the subject must remain 'objective,' tral,' 'passive.' This is an example of human plasticity. It took thousands of years for the human subject to attain this ree of plasticity, stretching itself to the point of translucency, so that The Real could pass through and presence itself on ording instruments that give us scientific results. The great achievement of the Greeks, was not the discovery certain scientific principles, but the capacity to render themselves 'absent,' or, in other words, vacate their subjectivity fore The Real. The ramifications, so prodigious, of this achievement have enthralled us to the extent that we have ome to believe The Real comes to us solely through science. The injunction 'be objective' in law, journalism, medicine, ven to a degree in Art, indicates to what extent we have turned ourselves over to this type of encounter. I would ke to stress that, with science, we have encountered The Real. It is not a matter of putting science in its place, ut rather showing that science already occupies a place, a very distinct one, vis-à-vis The Real.

The question becomes, what other dimensions of the Real are waiting to be encountered? This, of course, is not an abstract question, that is, it cannot be answered short of shifting our position in the stream. Here I stress 'encounter,' as opposed to perspective. An encounter differs from a perspective in that the latter connotes a position from which one perceives the world. An encounter connotes conjoining of subject and the world, the establishment of a circuit. The Real, from this framework, oscillates 'without limits,' generating an infinite number of open circuits. All of these circuits exist virtually. They have no reality until they form a closed circuit with the subject that likewise oscillates, but at discrete amplitudes, always between fixed limits. With that said, it may be possible that some humans, and some environments possess the capacity to form, or draw into actuality, simultaneously, multiple circuits with the Real.

tting emitting

thought

reflectingtra

nsmitting

This leads us to a discussion of Greiman's work as a colorist on three architectural projects by Roto Architects (Michael Rotondi and Clark Stevens). My goal here will be to focus on the methods she used in coordination with the designers to recover, through color, the circuits these buildings had formed with their environments that as a result of accident, reorganization, and neglect had been altered or destroyed.

The Dorland Mountain Arts Colony is located in the Temecula Valley Nature Reserve in California and about 100 miles from Los Angeles, 60 miles from San Diego. The colony is set on 300 acres along a ridge overlooking the Temecula Valley. The colony and its buildings cover about ten acres with the rest of the land left in its natural state. Its brochure describes the colony as "a primitive retreat for creative people. Working in a natural setting without distractions or interruptions, residents can tap into their inner resources. Without electricity, residents find a new, natural rhythm for their work." The project came to Roto Architectects as a result of a terrible episode. As I understand it, an artist of some stature had gathered together a large body of his work and moved it to one of the cabins. His idea was to sift through these works over a period of three months to decide how to best represent himself in what was to be a major exhibition. With the exception of a single propane lantern, the colony has no lighting other than natural. So, at night, the artist turned the lantern on, and then went to find a match. He must have been gone quite some time; long enough, anyway, to allow a significant volume of gas to accumulate in the room, because when he returned to light the lantern the a massive explosion ensued. The artist survived, but the entire structure and many of the surrounding trees was leveled down to the concrete foundation.

78

Real Spaces

time

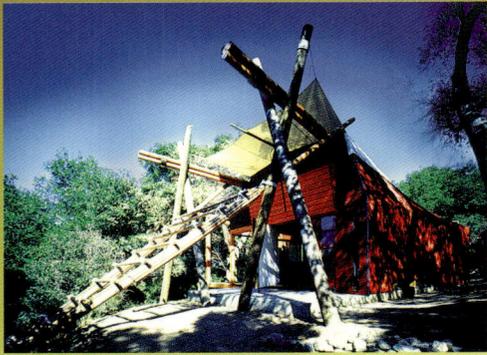

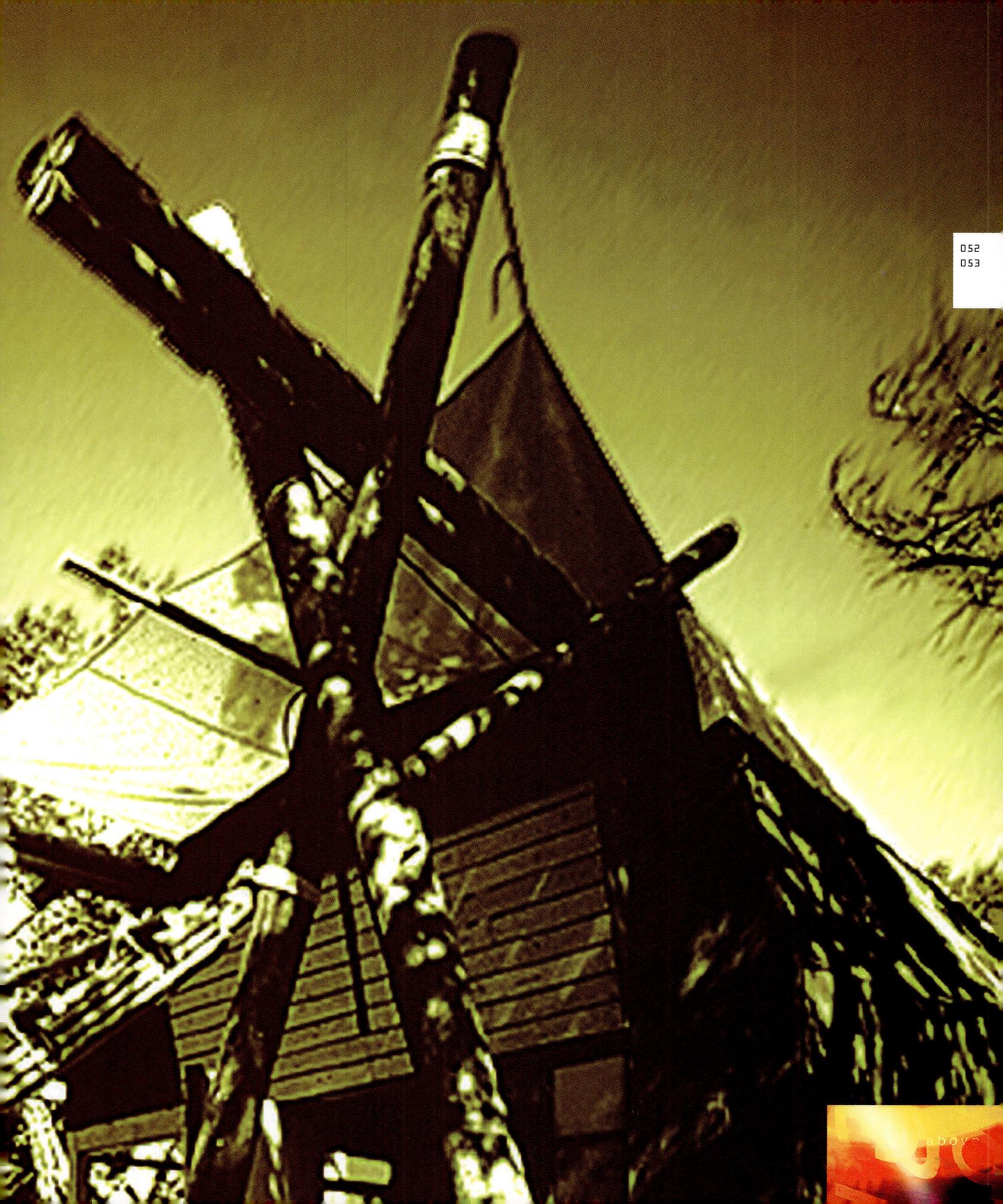

above

In choosing the colors Greiman and Roto Architects put the following questions to themselves. How can color participate with that particular site and the plant and animal life surrounding it? How can color aid the reintegration of the building, following the intervention, back into the environment? How can one retrieve, through color, the conflagration while at the same time moving beyond it?

A conflagration is destructive, but with that very destruction comes a creative burst, the very kind of burst that artists rely upon to ignite their own work. It is not surprising then, that the image of the Phoenix, the firebird that rises again and again from purifying ash, became a touchstone for Greiman's choice of exterior colors. For the siding, she and the architects chose red composition roofing roll material. The wood planes on the exterior of the building are colored orange. How light—the mood of the sky— might enter the place was another consideration. In order to effect a semi-permeable membrane between the inside and outside, the architects chose Teflon canvas for the ceiling/roof. The material is delicate and light-filtering to the degree that one can see the shadow of leaves that drop on it in the fall and the changing color of the sky, and durable and insulated enough to withstand harsh winter storms. For the interior palette, Greiman went around and gathered colors from off the mountain. The beams are stained bright yellow. The private zones, bathroom and kitchen, are also in more delicate colors, greens, browns, grays extracted from plant material. The idea, it should be emphasized, wasn't to copy nature, but rather to allow the building to participate in nature's creativity, its violence, its serenity. Whereas before the building was a hideaway in a secluded place, it now became an active participant with nature.

The old building was little more than a run-down wooden shack from the early part of the last century that hardly recognized the prodigious environs surrounding it. So, from the beginning, it was Roto Architects' intent to design a space sensitive to the energy of the mountains, something that would respect the way nature—the shrubs and trees, the deer and mountain lions and ants—shaped the space there, while simultaneously creating a building with a identity of its own. I haven't the room here to describe the building (for descriptions of all the buildings, refer to the images instead), but suffice to say, what went up is a virtual architectural homily on the transforming power of the creative act.

above

In choosing the color[...] Roto Architects put the follow[...] themselves. How can color p[...] that particular site, the plant[...] surrounding it? How can color[...] gration of the building, follow[...] tion, back into the environme[...] retrieve, through color, the c[...] at the same move beyond it?

A conflagration is [...] very destruction comes of [...] very kind of burst that [...]

The old building was little more than [...] The second project I would like to discuss is the Carlson-Reges Residence in Los Angeles wooden shack from the early part of the last[...] by Roto Architects. The architects were hired by the clients—an art collector and demolition contractor hardly recognized the prodigious env[...] specializing in dismantling industrial buildings—to rework their home, an eighty-year-old, steel-framed from the beginning, it was Roto Architects' intent to design concrete-wrapped Neo-classical box that was the machine shop of Los Angeles' first electrical power a space sensitive to the energy of th[...] station. The site itself is on the fringe of downtown Los Angeles, in an industrial no-man's zone—virtually in the cross-hairs of a major freeway and railroad that would respect the way nature—the shrubs and [...] tracks that lead into downtown. Looking beyond the freeway and tracks, one can see the Santa Monica and San Gabriel Mountains, and the city's skyline to deer and mountain lion and ant—sh[...] of the West. To design a permanent home in the middle such an inclement landscape was no mean charge, especially as the clients wanted to retain the simple while simultaneously creating a build[...] integrity of the original structure.

own. I haven't the room here to d[...]

descriptions of all [...]

instead), but s[...]

al homily on the [...]

Rather than alter the flow, it was Roto Architects' aim to work with it, to reorganize the spaces and the existing vectors issuing from and around the site. In analyzing the site, the designers found proximate and distant landscapes and structures—mountain tops, Dodger Stadium, skyscrapers downtown—with which they associated, through vectors' relationships with the building. Salvaged orphaned trusses, beams, and staircases around the site were recycled. A scrapped and colossal cylindrical gasoline tank was halved lengthwise and used for a lap pool supported on steel struts. By removing, rather than cutting and filling in, the old doors and windows, the old structure itself was allowed to participate in the vocabulary of the new building.

When all was said and done, the building, one of the most important architectural structures in Los Angeles, seemed to organically rise, without apology, from out of the motley landscape itself. The new building consists of three fluently linked stories, or rather three semi-translucent plateaus: a gallery for Art, a soaring middle main space that includes the kitchen, dining and living rooms, and the upper floor, the sleeping quarters. Greiman's earliest experiences of standing in the main space produced for her a kind of dèja vu, a feeling that she had been at that place before. She had a similar feeling, she explained to me, standing at the bottom of the magnificent Titus Canyon in Death Valley: awe and intimacy, lightness and grounding, depth and verticality, muscularity and economy—the encounter of one's own complex structure at a much larger scale. The naïve observer, looking outside would be hard-pressed to make the connection between the building and nature. Still, towards the end of naturalizing the structure's dynamic upward climb, organizing the multiple planes and multiple vectors of the interior beams, and expressing the sculptural massings; this is the connection, she believed, colors were required to make.

Sections of the old building articulate with the new. To give continuity to the old and to express the difference between it and the new structure, as well as to maximize the use of a bright white where needed, she painted the pre-existing concrete walls in Navajo white. To establish the balance of the color palette, she went, bug-like, searching outside with the goal of finding natural colors imbedded in the industrial landscape.

From various rock surfaces, she extracted lichen of various hues—the only colors she would use. The Main space, with its original cherry flooring, she colored for fire. The massing of the fireplace itself, the centerpiece of the main space, went bright ochre. For the kitchen she chose the lightest aqua blue imaginable, water cool, the color of lichen she skimmed off a concrete slab. The media center—a rectangular box partially clad in a kind of second skin—the architects had float above the dining room.

Greiman's aim was to give both density and levity—quite literally 'make light of weighty matters'—to this gesture. The box she painted purple-brown, and then to lighten its load, she painted the skin an even darker color. The beams were stained *Anubis*, the blackish color of Egyptian statues. The upstairs sleeping quarters give an unbounded, 360-degree view of the city and beyond. Greiman's aim was to ground this space by staining the cabinets gray-green, the color of some moss.

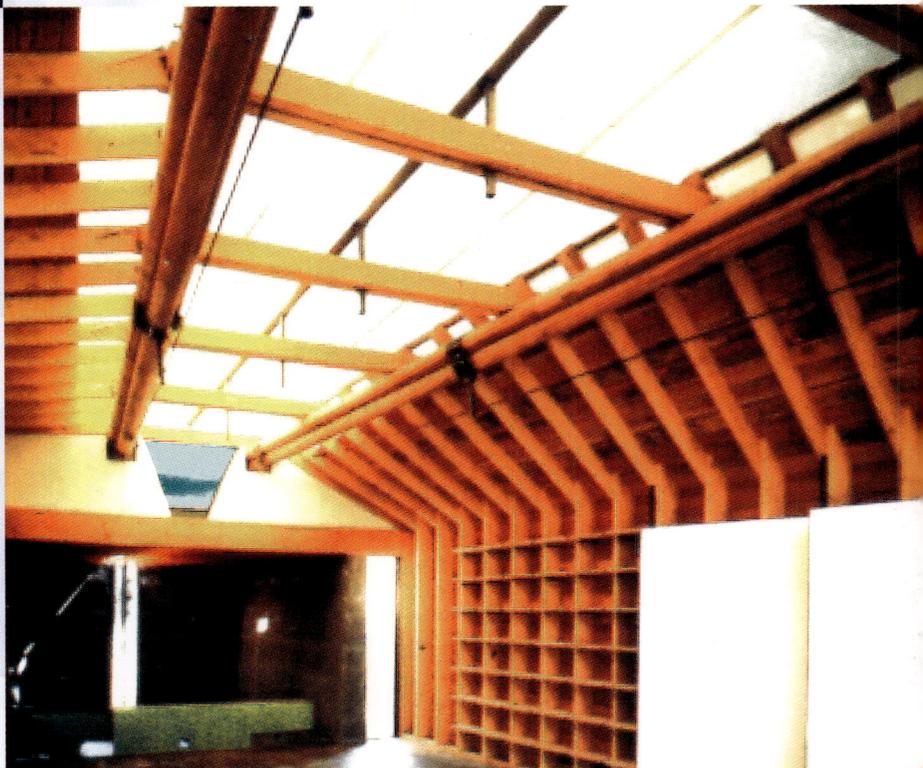

above

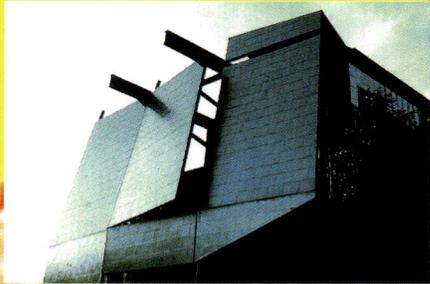

above

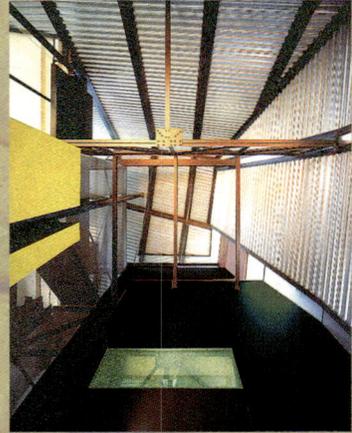
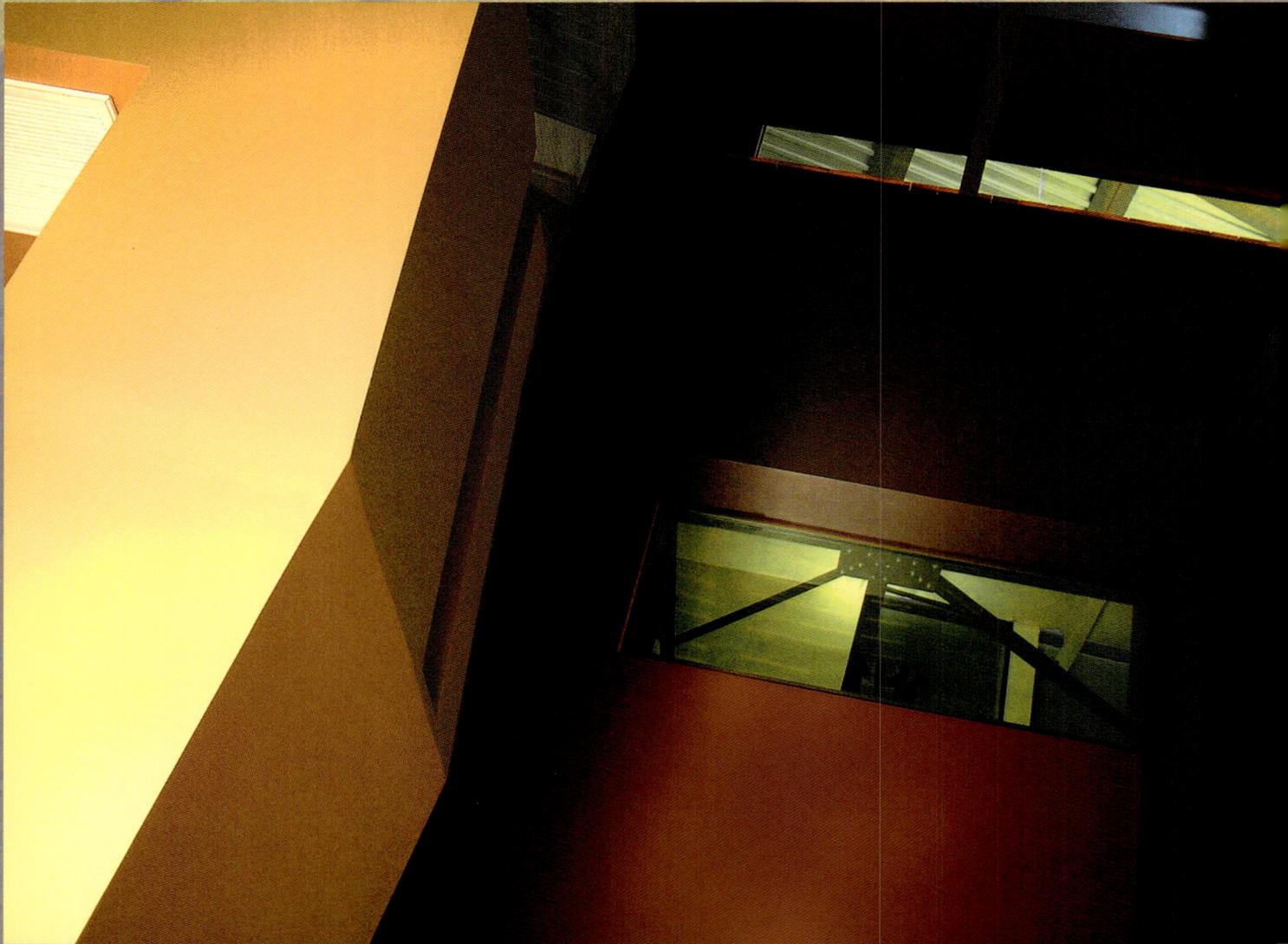

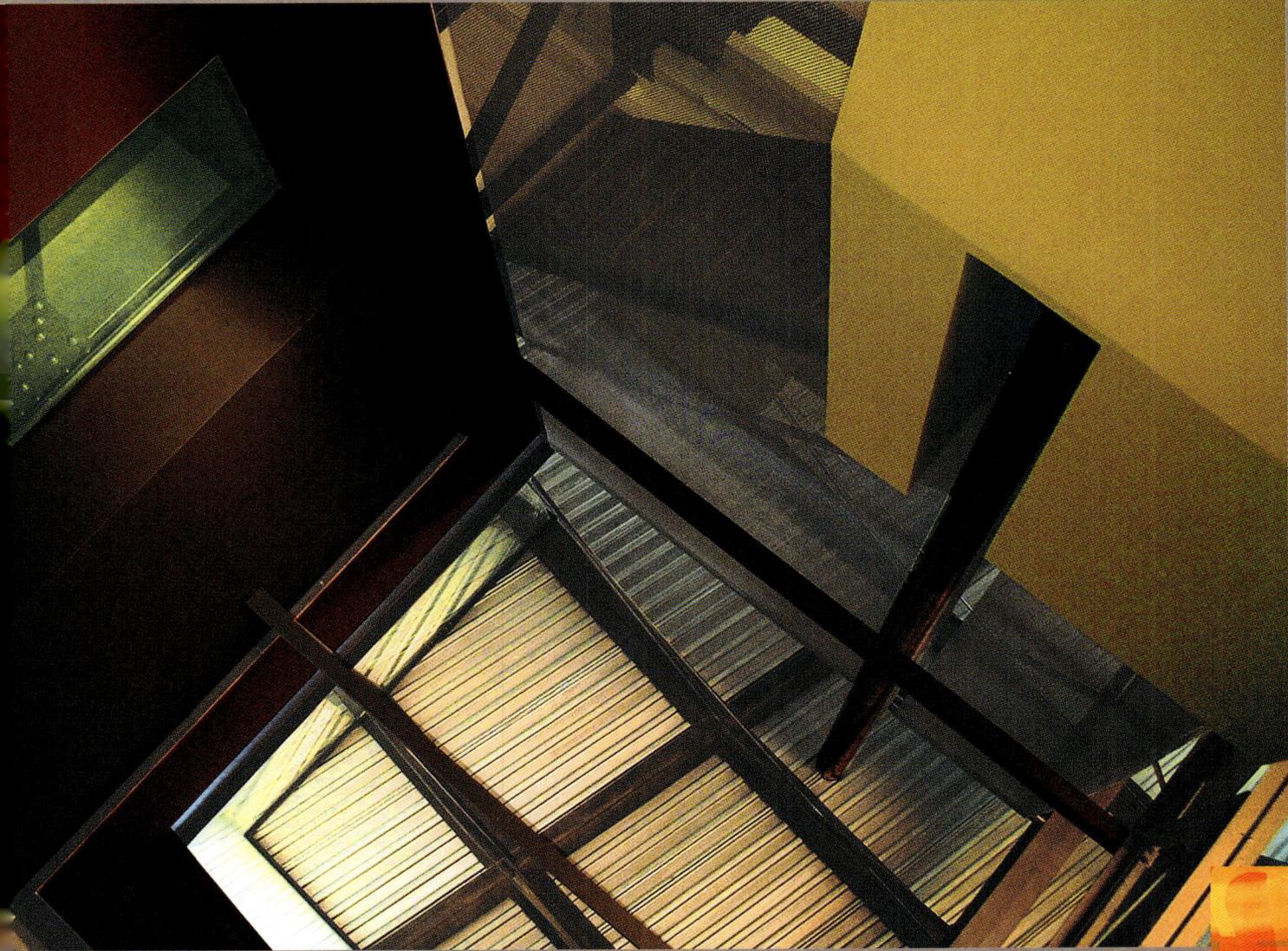

above

above

and

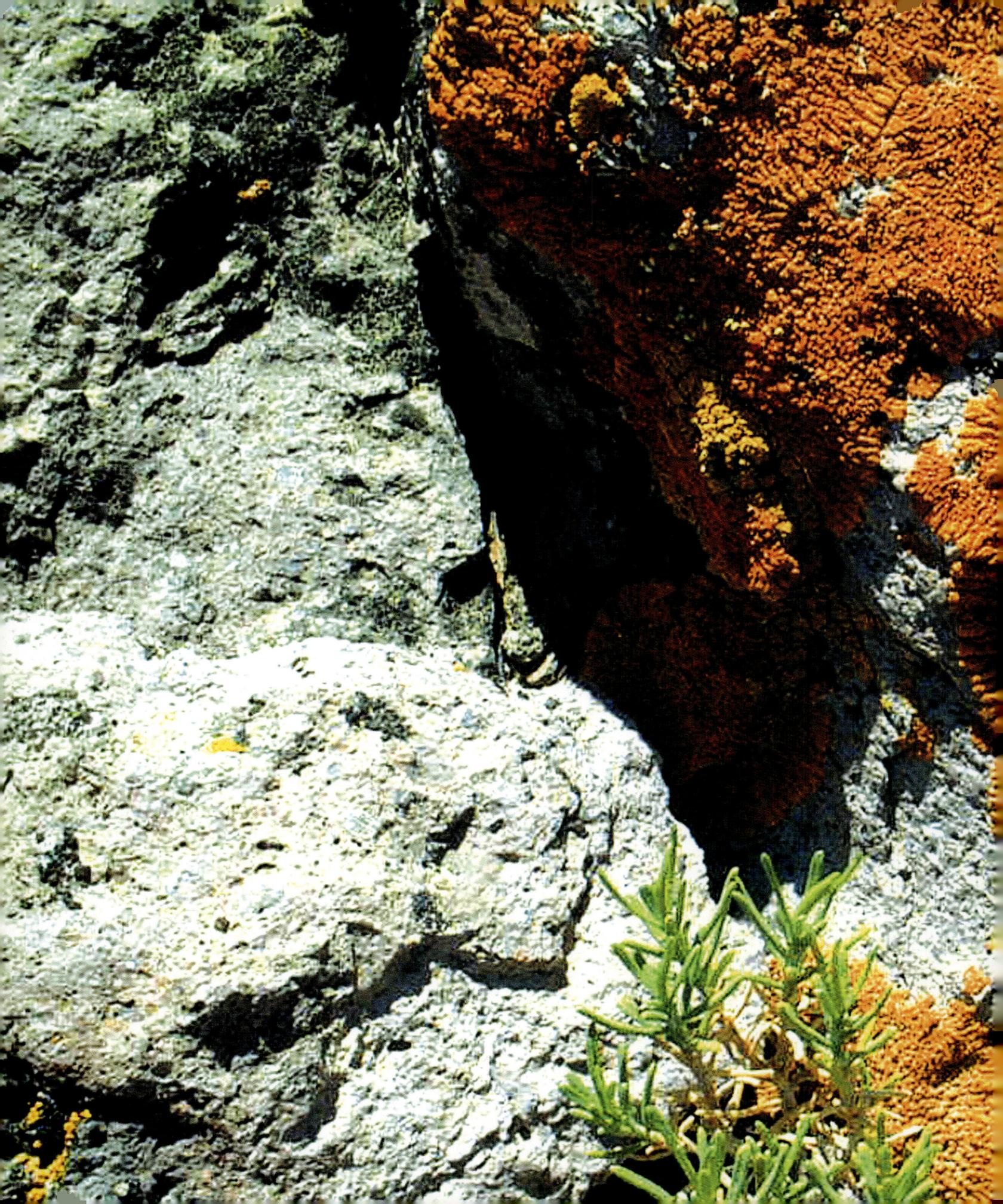

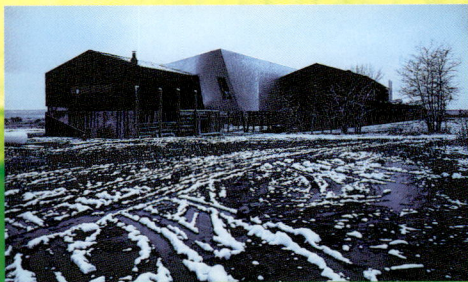

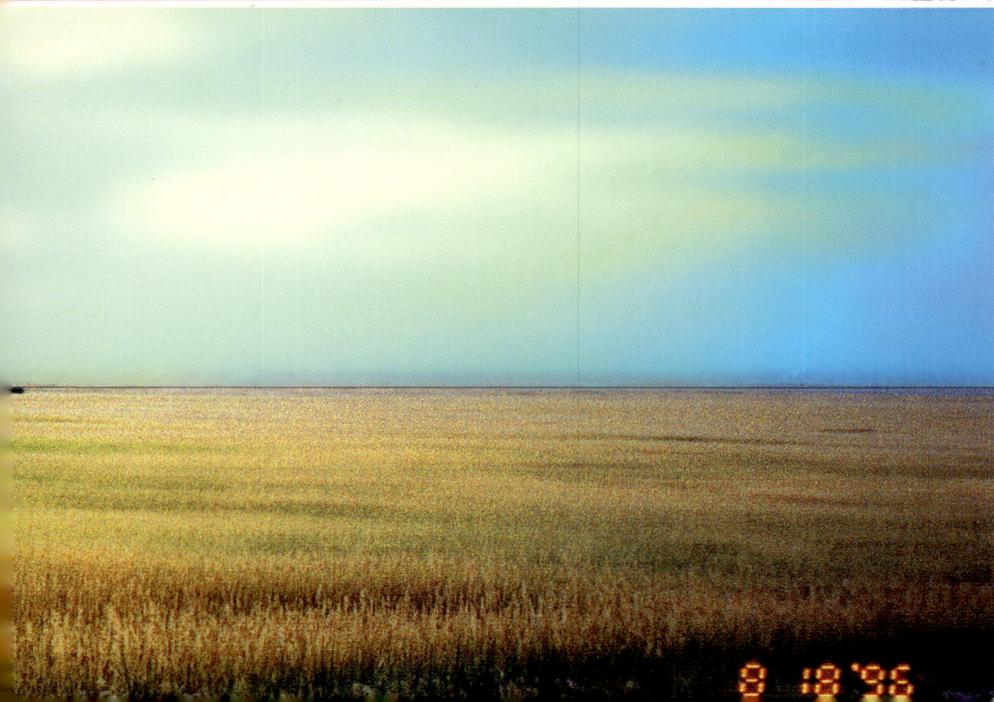

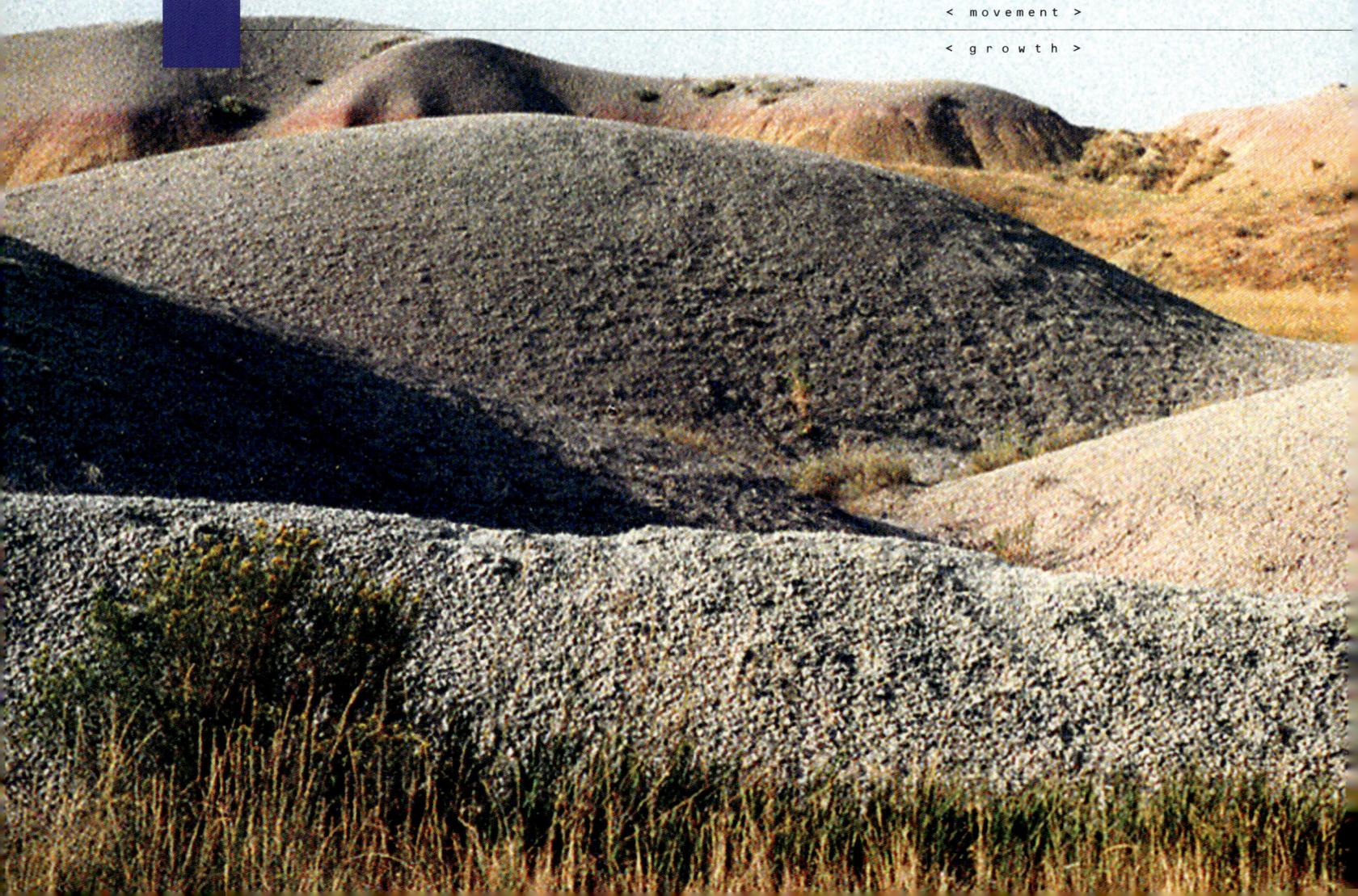

the h o r i z o n

< movement >

< growth >

SKY = takuskanskan

the point of all creation

makaina = EARTH

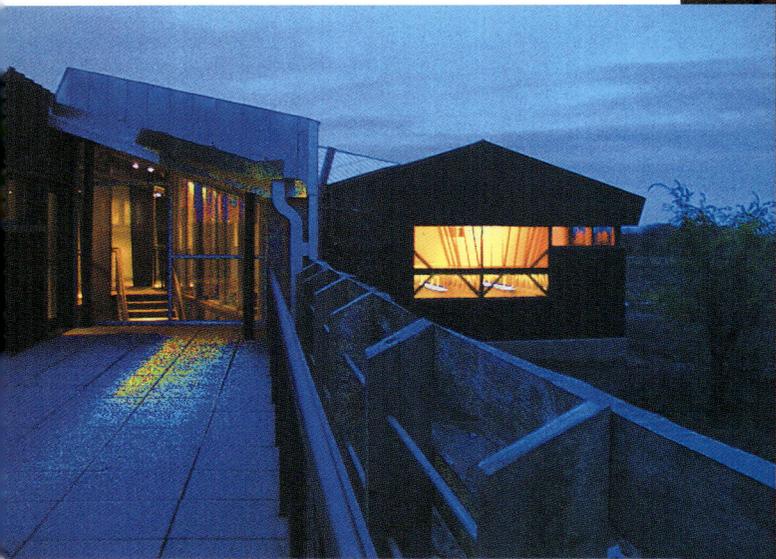

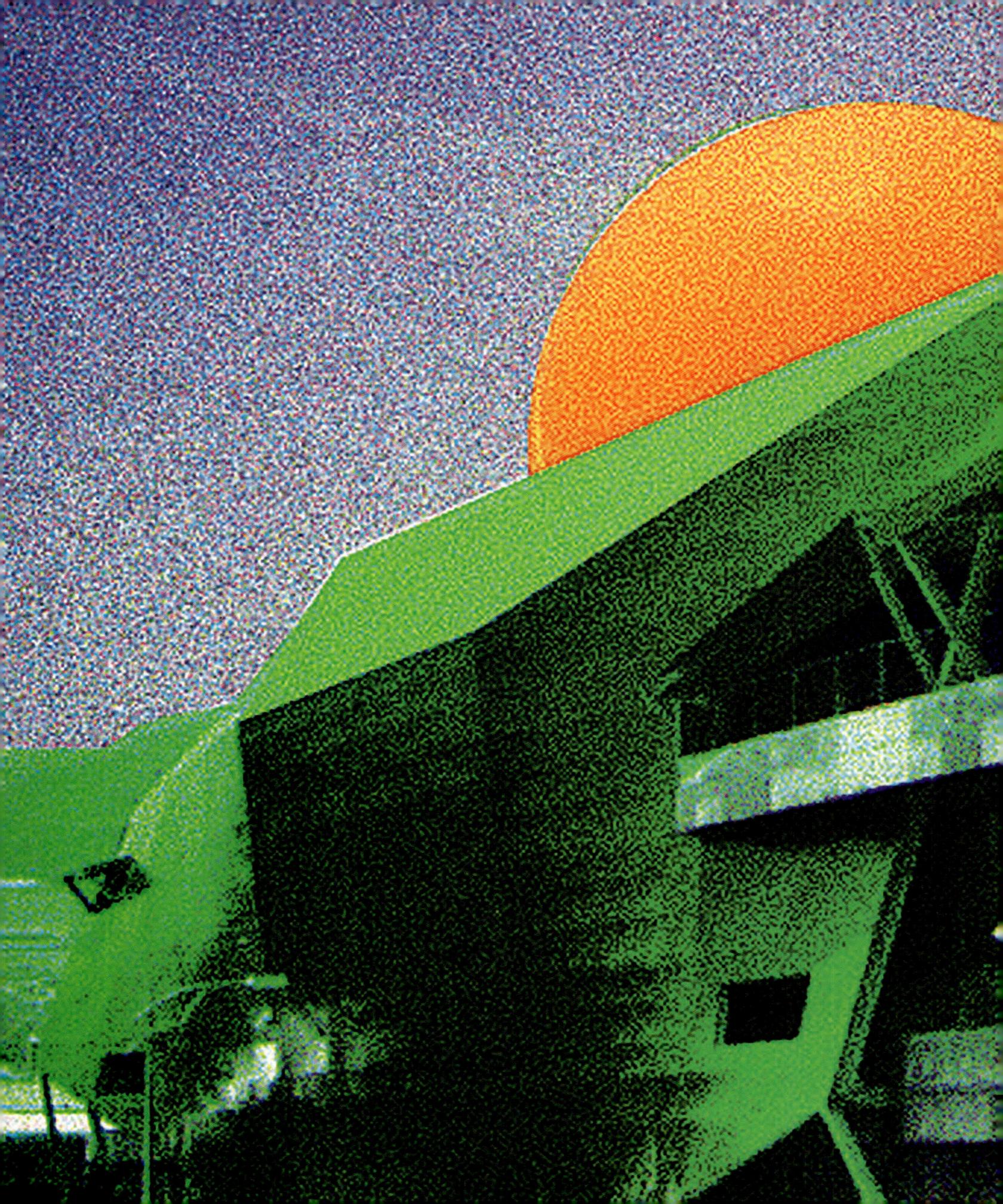

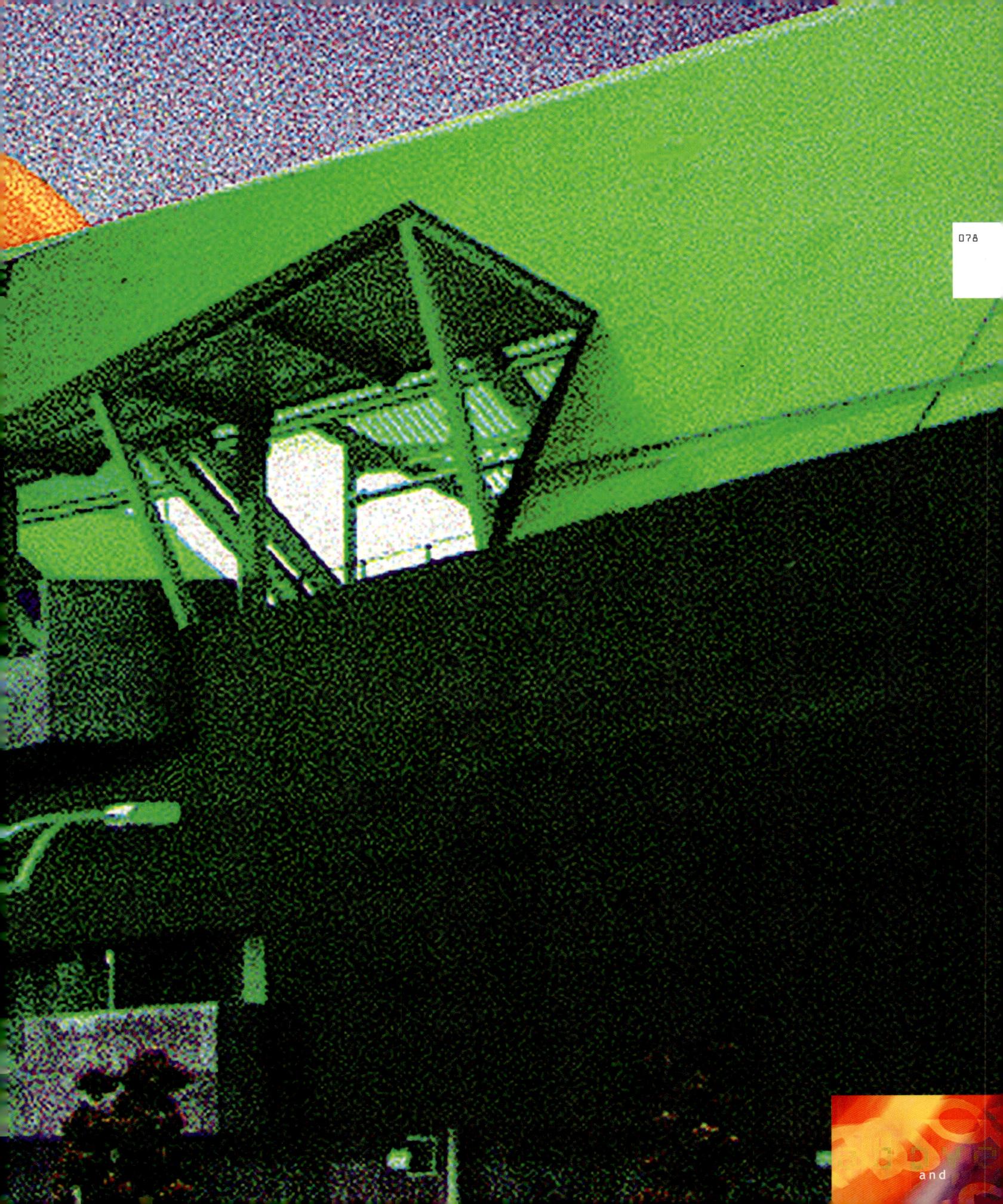

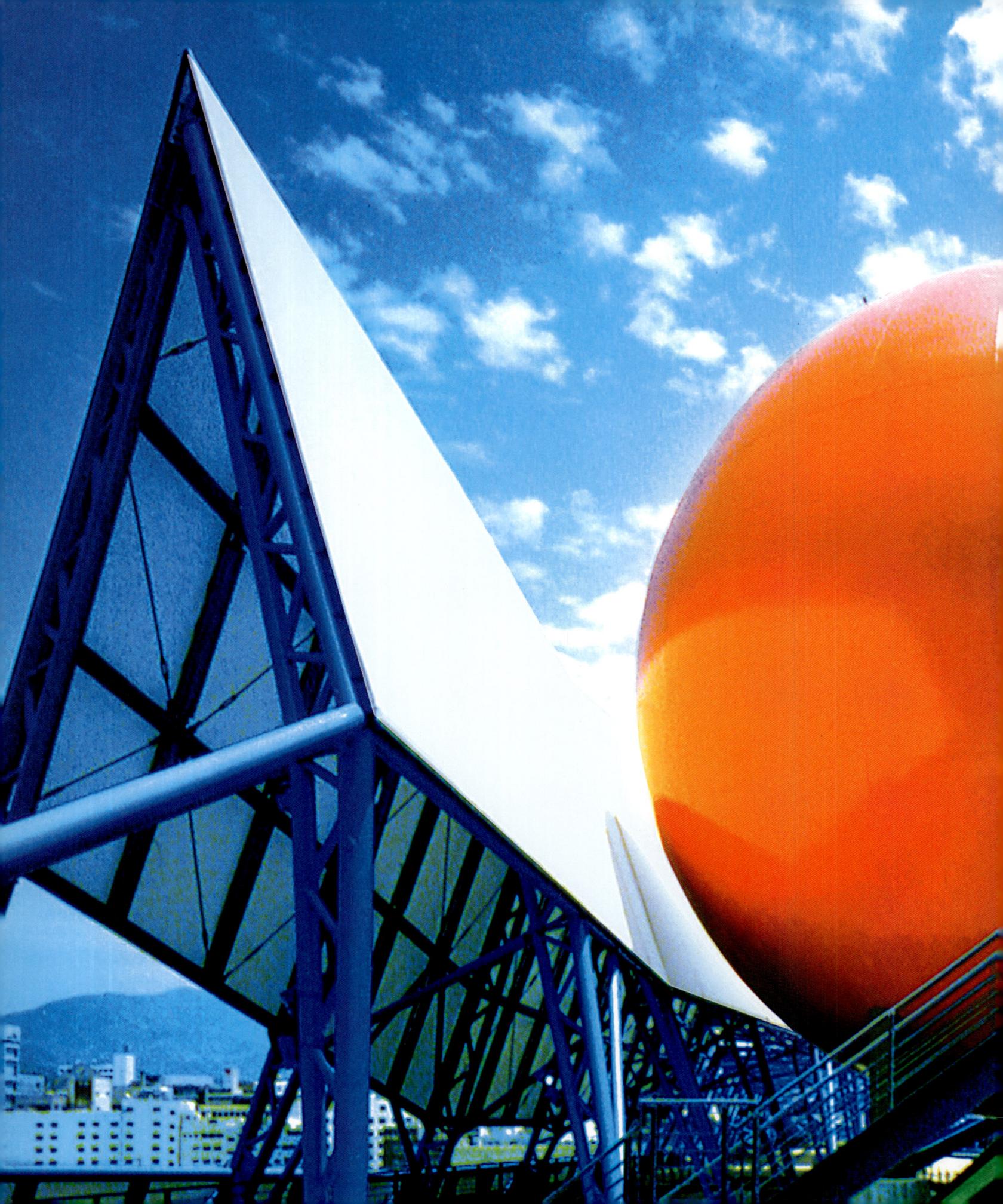

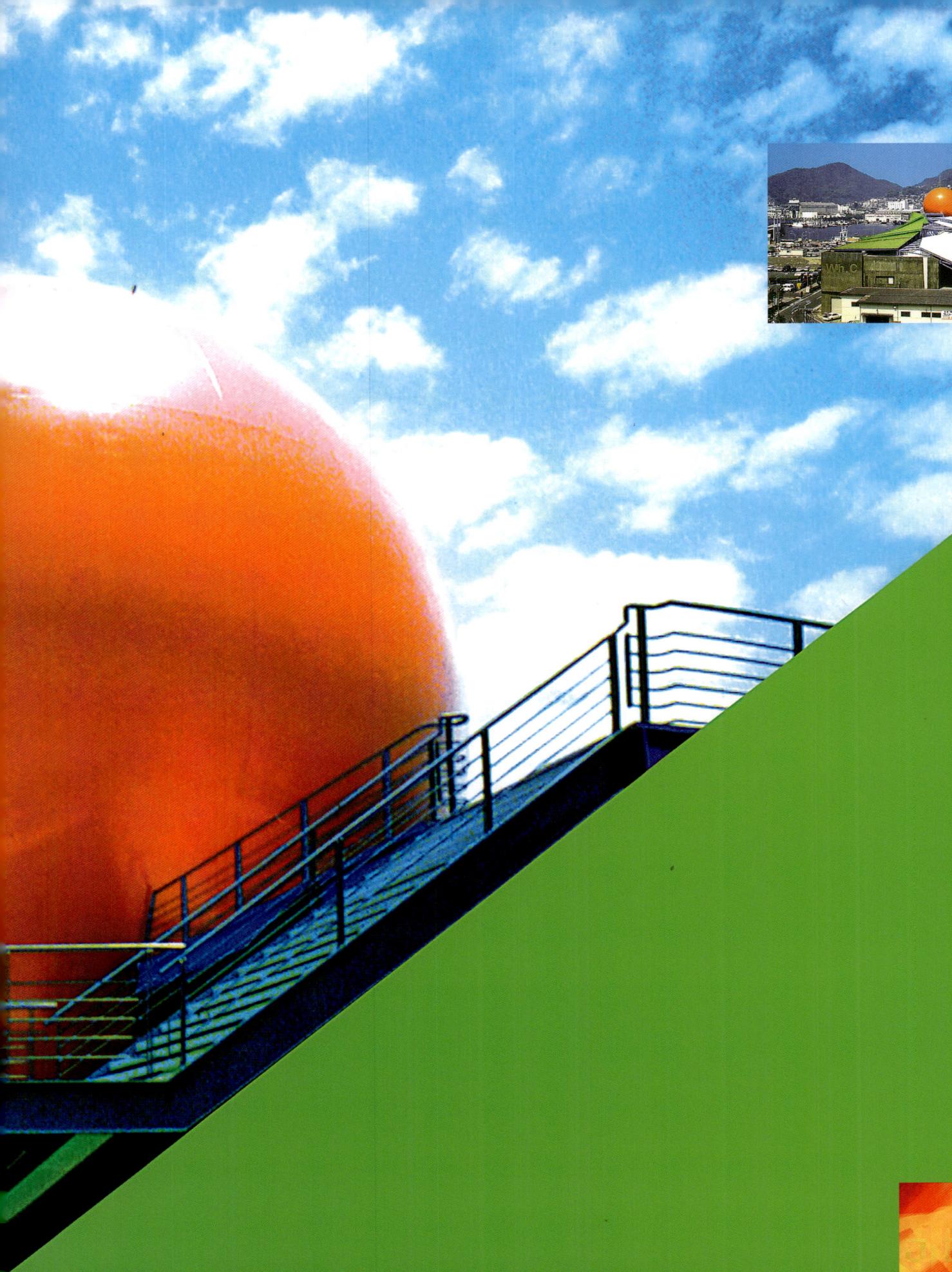

and

CAUTION
ONE WAY ROAD
BOTH WAYS

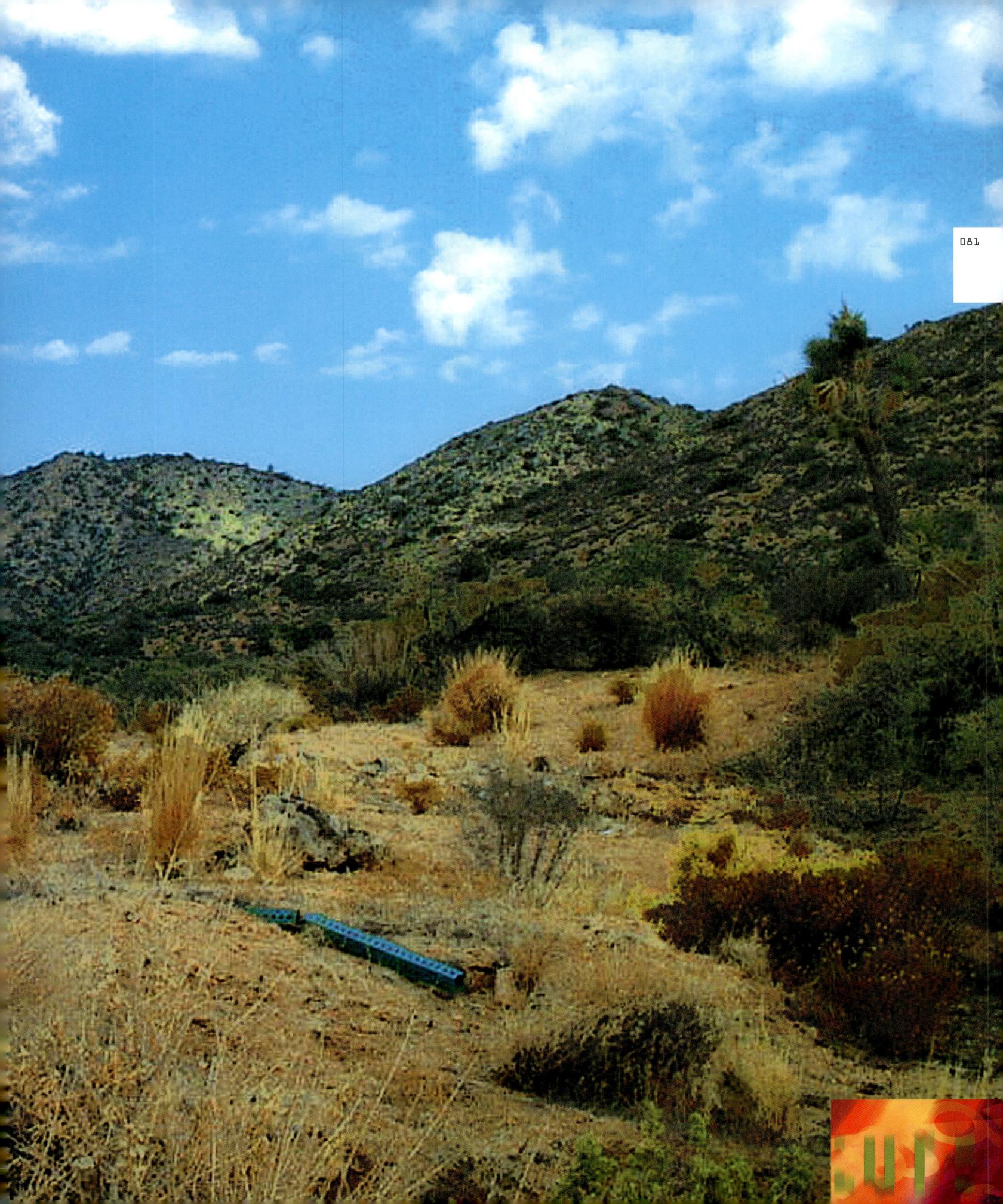

The last architectural project we will discuss is Miracle Manor Retreat, located in Desert Hot Springs, one of a handful of down-scale resort cities neighboring Palm Springs, about 100 miles East from Los Angeles. For years before taking title as owners, Greiman and Rotondi were regulars at the hotel. They came there for the water that rises up from between fault lines at a temperature of 158 degrees Fahrenheit, which has been described as "cleansing," "healing," and "very wet." The hotel they patronized then was plain. Seven cinderblock rooms formed together a kind of cocked U, at the opening of which was the regular and hot-water pool. The interiors were a weathered hodgepodge of furniture, color and textures. True to the American experience, the centerpiece of each room was your obligatory TV.

The view, however, was beautiful. From the hot spring pool, one looks upon an expanse of desert, a flow of land inflected with cactus and creosote that runs up to a monumental sierra. As the sun dips below the mountain, alabaster and then ever-deepening hues flood the desert floor.

Architecture has traditionally worked to bring time to a standstill, to contour space around the building, to take, in effect, the building out of the flow. The architect has been the mastermind behind the erection of stability and certainty, she who raises out of and against the flow of life, immutable forms; much as, for Plato, the cosmic artificer shaped from chaos the orderly cosmos. Greiman and Rotondis' goals when they began converting the hotel into what they would call "a retreat," were precisely opposite to that: to get the building to join the flow of information/energy that surrounded it. Rumor had it that natives migrating from the Morongo Valley to the East would pause at that spot before they began their descent. When Greiman and Rotondi surveyed the landscape, they found that Miracle Manor was situated on a plateau, a resting place between higher and lower ground, that moved East to West. They wanted, first, then, to negotiate a space that respected the natural flow of energy moving in that downhill direction, a place of calm in the stream of movement; to treat the retreat as an extension of the desert itself, but with its own distinct identity, just as every plant has an identity, every stone, every bug. They also charged themselves with synchronizing with the life-forms of the desert, which over millennia have evolved attributes of economy, directness, and simplicity for survival. Time also was a consideration. In the desert it goes slow. Everything is moving, changing, but at an almost imperceptible rate of speed.

With these characteristics of the desert in mind, they stripped the interiors of the hotel rooms of all that was unessential to rest, scraped away what had been applied. Out went the shag carpets, and instead, to break down the idea that the desert is hot and dry and non-sensual, for flooring they used large squares of plywood, warmly lacquered, with borders of cool self-leveling cement. The air-conditioners that were plugged into the windows, gone. Nothing should obstruct the view of the desert, so down went the gaudy drapes. The windows that run the length of the room on either side allow for privacy, while creating an opening for light to bathe the space with the same fullness as it does the landscape. In place of a TV, a small rough-hewn bench, and beneath the window a long work table attached to the wall, completed by a simple Eames chair. The goal in choosing the paint color for the interior of the rooms was to match the frequency of the landscape outside. Greiman gathered samples of sand from the desert, and blended them to get a calming earth-toned hue. The bedding is made of organic cotton textiles of the same color as the paint in the rooms. Inside and outside oscillate at the same amplitude forming a single circuit: plant, mineral, mind, soul—explicate moments in an implicit order.

When you step outside of the rooms, you are drawn down toward the hot spring spa, a plateau within a plateau. The spa sits in a transparent glass-like enclosure, so that from in there it is as though you were in a fishbowl looking out. The designer's idea was to create a space inside of a space that shared in the same medium, an eddy within an eddy within the same stream, but also to turn space from a thing one occupies to an 'event' one participates in. From the enclosure you slip through an aperture, a window, into the regular pool, considerably cooler than the 105 degrees Fahrenheit temperature of the spa. The change of temperature is luxurious, bracing. And again, what changes is the density, the thickness of the medium, not the medium itself.

After several generations of trying to secure the world-out-there at the expense all else, such encounters are indeed a miracle, a respite to the self that over the past two hundred years has been mercilessly left with little other than its own image to touch and ponder. Such encounters are like the experience of love, that human attribute that survives the depth model, even the death of God, a feeling/drive which makes us reach beyond ourselves, our own structure, and opens us to the structure of things Other than us.

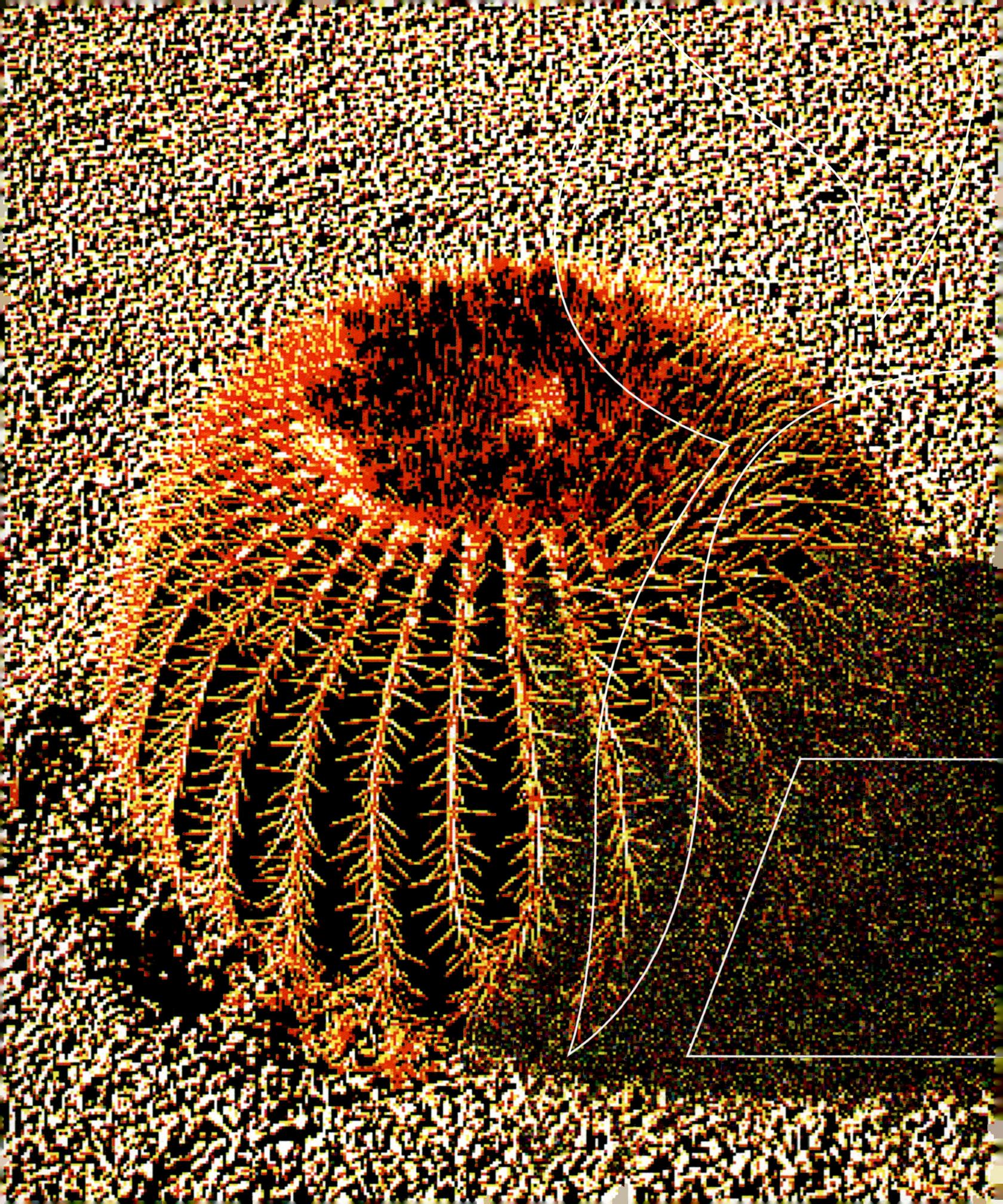

miraclemanor.com

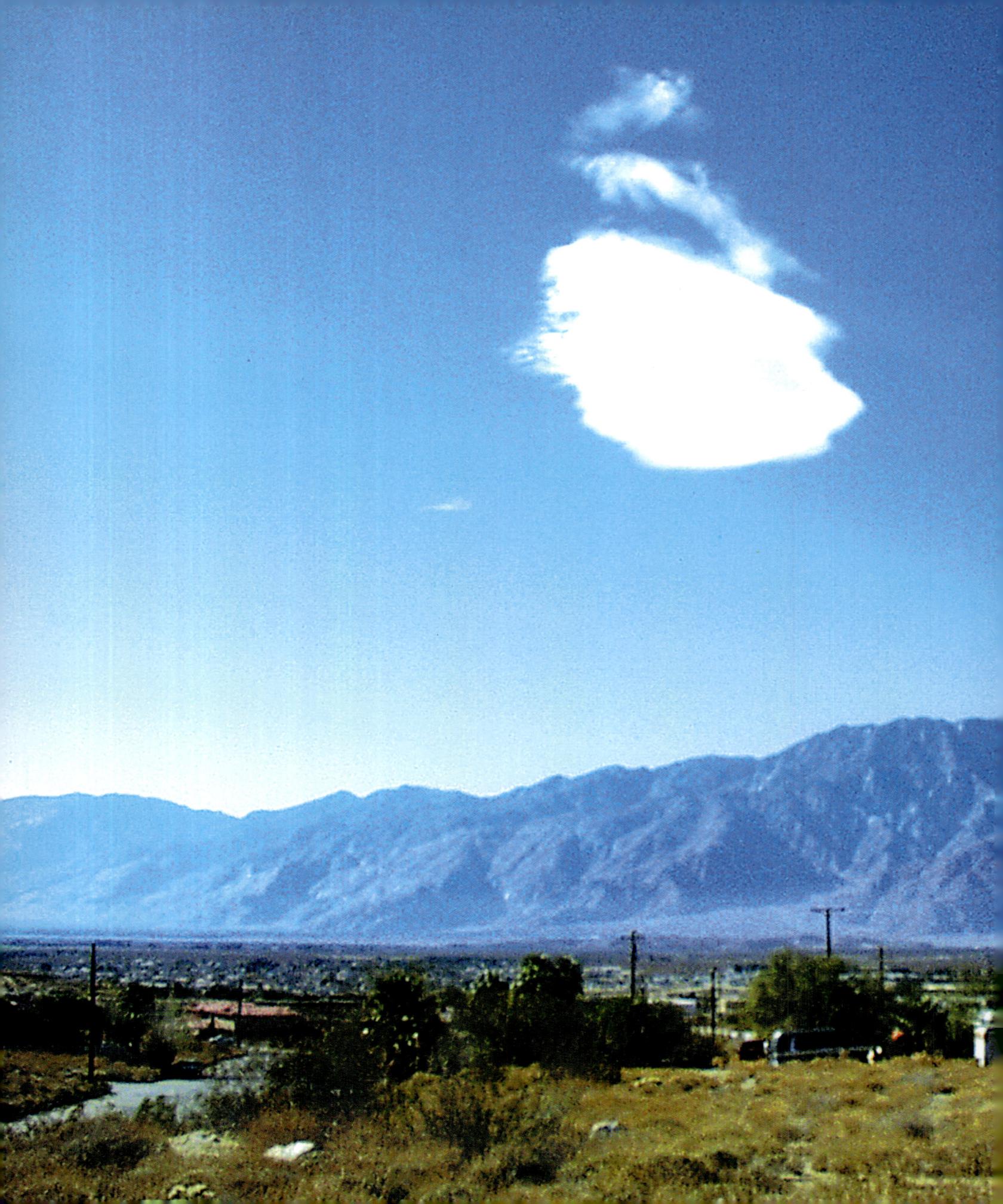

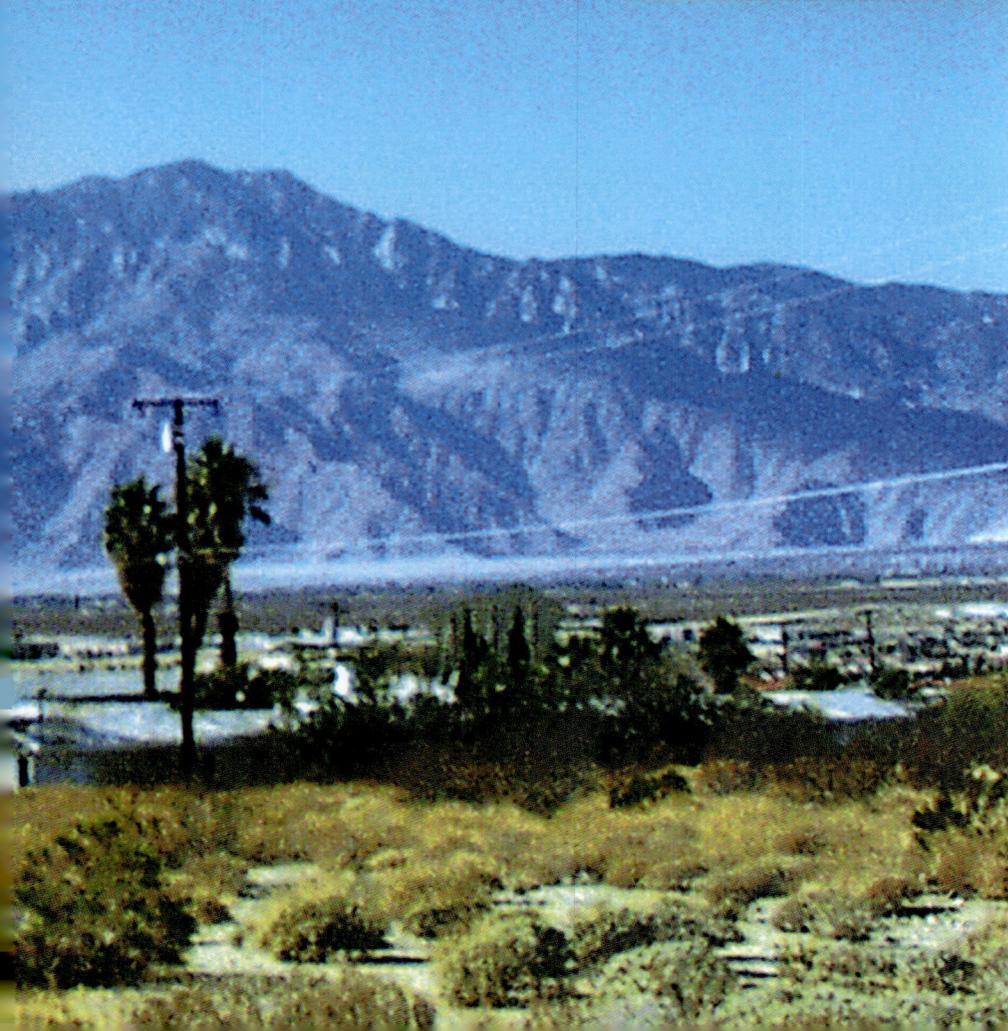

miracle manor retreat

Natural Hot Water Analysis

877 329 6641

silica	021.50
iron oxide	trace
calcium	045.10
aluminum oxide	trace
magnesium	005.10
sodium	268.60

sulfate	493.60
chloride	120.50
bicarbonate	129.00
fluoride	005.30
hydrogen-ionactivity (pH)	008.30
conductivity (EC 10⁶ @ 25⁰ C)	388.00

DHS

Desert Hot Springs, California

L.A.

S

E

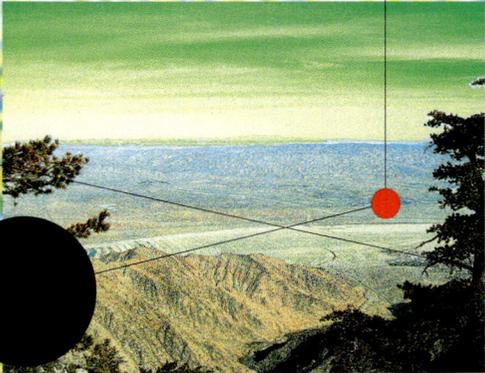

Mount San Jacinto
elevation : 10,100 feet above sea level

nature

nature

...IN THE

OF

100% ORGANIC

MIDDLE
THE DESERT
Miracle Manor Retreat

above

158°
F

109
110

above

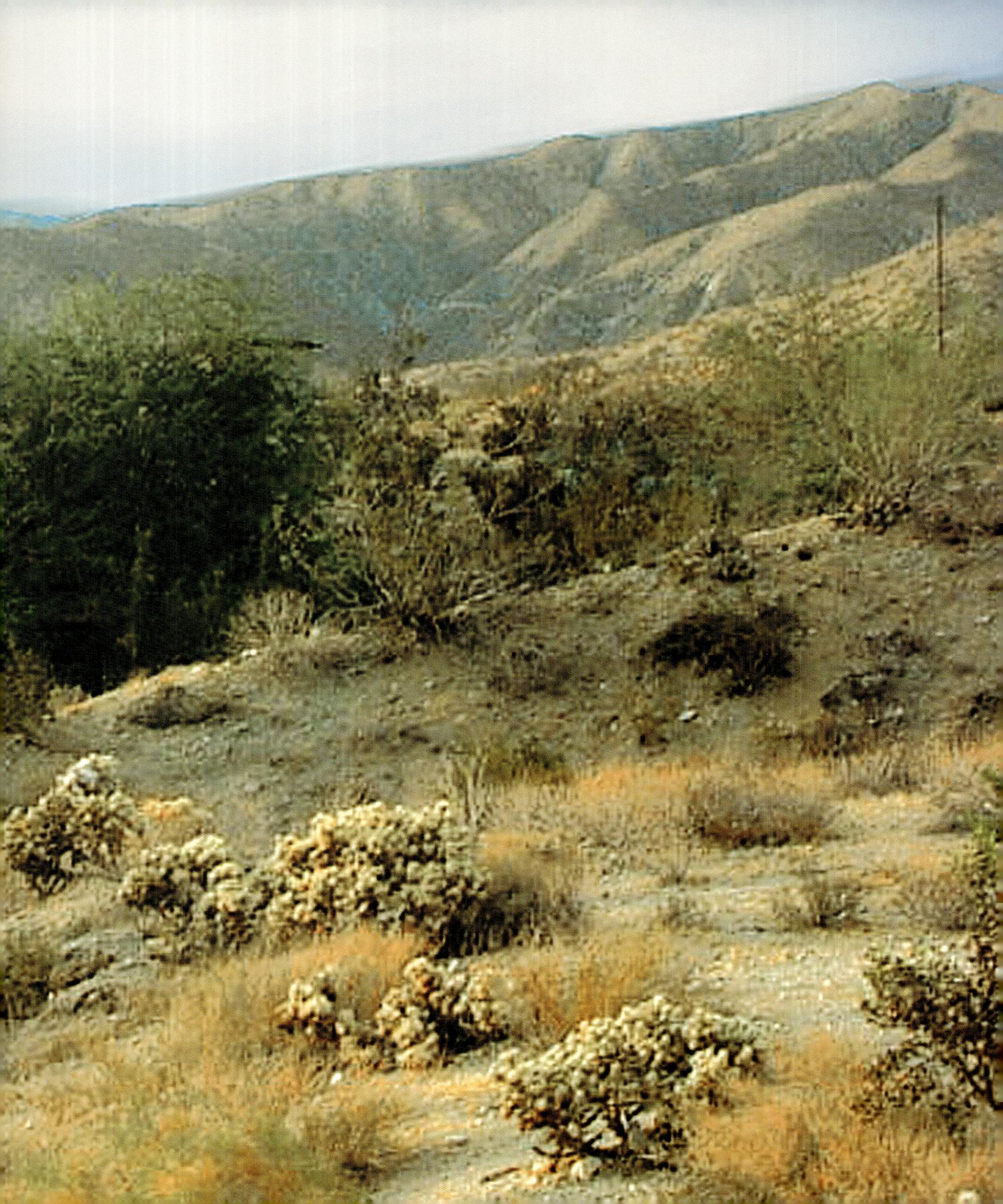

144

About this Book. How to Read it, etc.

About this Book. How to Read it, etc.

6 / 26 / 01

Reading is a kind of encounter. Approached with the proper degree of courage one opens oneself up to a world, a perspective, a foreign body that increases one's sense of the Richness of the Real. But the writing of a book, we believe, should also be an encounter. Authors, so that they do not betray the message they want to communicate, should expect of themselves no less than what they expect of their readers. Frequently books of the sort we have written here—a mix of criticism, philosophy, images, illustrations—tend to pry The Real apart, challenging the reader to re-see the world, even as the book itself closes in upon its own world in order to establish its authority. The reader is often faced with a disquieting sense that the preacher failed to live what he spoke. To avoid this hypocrisy, it is a temptation on the part of authors—even those who are aware of such dangers—to make the book a faithful replica of the ideas they hold. We find such books, the way models in miniature tend to be, weirdly obvious and stiff. So, rather than trying to make this book be what it says, we aimed at making a book that participates in what it says.

Reading is a kind of encounter. Approached with the proper degree of courage one opens oneself up to a world, a perspective, a foreign body that increases one's sense of the Richness of the Real. But the writing of a book, we believe, should also be an encounter. Authors, so that they do not betray the message they want to communicate, should expect of themselves no less than what they expect of their readers. Frequently books of the sort we have written here—a mix of criticism, philosophy, images, illustrations—tend to pry The Real apart, challenging the reader to re-see the world, even as the book itself closes in upon its own world in order to establish its authority. The reader is often faced with a disquieting sense that the preacher failed to live what he spoke. To avoid this hypocrisy, it is a temptation, on the part of authors—even those who are aware of such dangers—to make the book a faithful replica of the ideas they hold. We find such books, the way models in miniature tend to be, weirdly obvious and stiff. So, rather than trying to make this book be what it says, we aimed at making a book that participates in what it says.

usualorganizationoftextandimage

This aim of ours may help explain why those of you who hoped to find in these pages an overview of Greiman's work, a series of images with corresponding captions and descriptions, that walked you front to back the high points of her career, might be disappointed. Although we tried to be sensitive to the reader, to not allow the text to float alone on its own without some grounding with images, we also did not want to recapitulate, yet again, those things that have become familiar to us, even if they were not familiar to you.

The unusual organization of text and image for this book may be a challenge to the reader as well. By far the more usual way of going about this organization is to illustrate, that is, bring to light, illumine, the text through the images, or conversely, the images through the text. While allowing that some books might need to be written this way (e.g. technical manuals, school books), for our purposes this approach seemed stifling. Another way to organize text and image is to stress disjunction, ambiguity; to keep the two things separately coded, or coded at such a 'deep' level that all but the most serious reader will be left scratching his head as to what's going on. This track, evident in many 'artists' books,' didn't interest us either. Aside from the fact that it makes reading difficult, even tortuous, a kind of pretentious, *catch-us-if-you-can* attitude is established with the reader that perpetuates the shopworn myth of the artist as he who, as Joyce put it, "like the God of creation, remains within or behind or beyond or above his handiwork, invisible, refined out of existence, indifferent, paring his fingernails."[10]

the only two options available to us

We do not be clarity

do not believe that either clarity or obscurity are the only two options available to us. In the course of these pages,

we have, we hope, given indications of not only how one might read Greiman's work, but the world-out-there with

which it is connected, and The Real of which it is a part. This world, wholly available to us, is increasingly shuttered

from our view, and sadly, certain artists activated by the very inertia which they engender, are responsible for keeping the

openings closed, even as they grope for another King, sitting within reach, to depose. We believe the idea is not to

depose the King, but to leave him altogether, go abroad, migrate to wholly new horizons in search of encounters. In

that spirit, we wanted text and images, as distinct matrices of information, to migrate toward each other, exchange

information rather than clone or obscure each other. There was no plan, on either the writer's or the image-

producer's side, to coordinate in advance what would happen. The book proceeded step by step, in a kind of dance,

with text and image now stumbling, now flowing with each other. It was our goal to create a book made of **discrete**

moments synchronized across, but not harnessed by time. And as for the reader, we hoped to bring into

being a book that is a body, identical to itself, but also eager to form circuits with you.

The same spirit imbues Greiman treatment of her own work over the course of these pages. A close reading of the image of the Atom Bomb exploding in Los Alamos, in the early part of this book, provides us, I think, with an example of her approach.

The same spirit imbues Greiman's treatment of her own work over the course of these pages. A close reading of the image of the Atom Bomb exploding in Los Alamos, in the early part of this book, provides us, I think with an example of her approach.

If you will notice, photographers stand, like supplicants, before the bomb, intent to capture at any price, to save for posterity, that single, fearfully beautiful moment, the release from potentiality into actuality a dimension of The Real that would alter everything that followed. Behind the photographers, outside the reach of our eyes, was positioned, probably, an officially stamped government moving camera. The moving images captured by that camera, was shown some fifty years later as part of a TV documentary on the Atom Bomb. Greiman watched the documentary one night, and stirred by the images, took a camera, a snap-and-flash, and from the relative safety of her living room couch, captured the image herself off the TV screen. She then transferred that photograph to the computer and after moving what she calls "pixel debris" out of the way, rendered it for this book. Sundry implications are enfolded in the all this, for sure. But for the aim of our present discussion, Greiman's treatment of material for this book, I will stick to unfolding one or two.

If you will notice, photographers stand, like supplicants, before the bomb, intent to capture at any price, to save for posterity, that single, fearfully beautiful moment, the release from potentiality into actuality a dimension of The Real that would alter everything that followed. Behind the photographers, outside the reach of our eyes, was positioned, probably, an officially-stamped government moving camera. The moving images captured by that camera were shown some fifty years later as part of a TV documentary on the Atom Bomb. Greiman watched the documentary one night and, stirred by the images, took a camera, a snap-and-flash, and from the relative safety of her living room couch, captured the image herself off the TV screen. She then transferred that photograph to the computer and after moving what she calls "pixel debris" out of the way, rendered it for this book. Sundry implications are enfolded in all this, for sure. But for the aim of our present discussion—Greiman's treatment of material for this book—I will stick to unfolding one or two.

If you will notice, photographers stand,

like supplicants, before the bomb, intent

to capture, at any price, to save for

posterity, that single, fearfully beautiful

moment, the release from potentiality

into actuality, a dimension of The Real

that would alter everything that followed.

Behind the photographers, outside the reach

of our eyes, was positioned, probably, an

officially stamped government moving

camera. The moving images captured by

that camera, were shown some fifty years

later as part of a TV documentary on the

Atom Bomb.

Pictures, for Greiman,

multi

For Grei

for th

Pictures, for Greiman, **are shards of time,** time-slices of some original explosion that transmit information across multiple dimensions. It is we, in our obsession with certainty, who 'fix' the photograph even as we 'fix' ourselves. For Greiman her past projects contained the genetic information for this project; **eachpixel-genecarriedwithinit**information on its past, **present,** and **future body.** Greiman was not interested to clone, to duplicate images of her work, but rather re-encounter her own work, rework it if necessary, by drawing information enfolded inside of it for presentation in this current project.

Semioticians and Post-structuralist critics revel over such anecdotes as the one described above, because it seems to tidily demonstrate their contention that there, 'is no essence' to things, that as objects shift context intrinsic identity is neutralized or disappears. From their perspective, the object we are left with is a rootless, floating signifier, something that can be picked up and reorganized in different linguistic economies. We agree that objects, words, images, possess this kind of plasticity, but not because they are rootless so much as because they are rooted in multiple ground, ready to assemble into other bodies already. As we see it, against the Post-structuralist perspective, a thing, including ourselves, does not possess a single essence, but many essences waiting to unfold.

shards of time, time-slices of some original explosion

e dimensions. It is we, in our obsession for certainty,

who "fix" the photograph even as we "fix" ourselves.

her past projects contained the genetic information

each pixel-gene carried within it information

oject, each pixel-gene carried within it information

of its past, present, and future body

of its past, present, and future body.

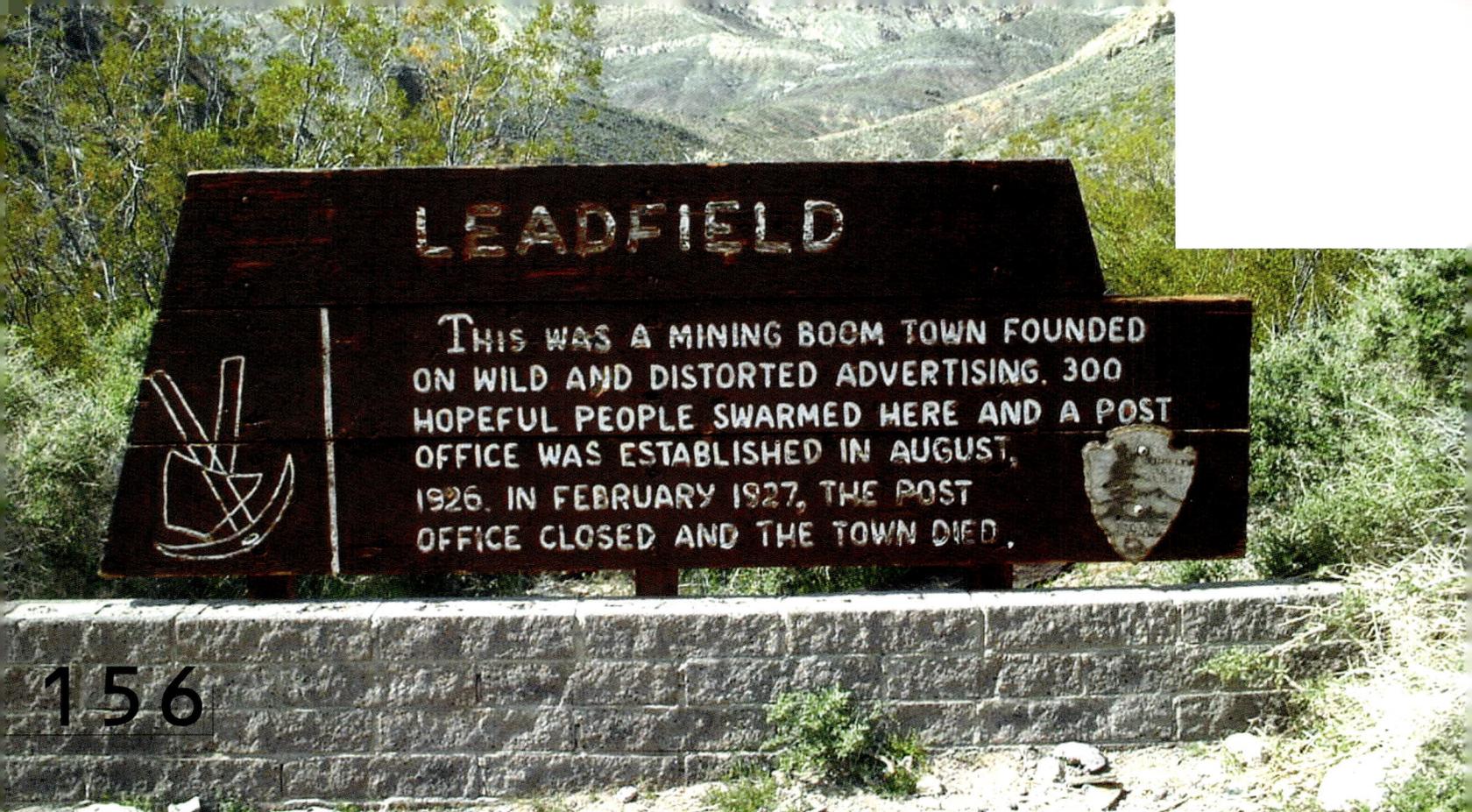

LEADFIELD

THIS WAS A MINING BOOM TOWN FOUNDED ON WILD AND DISTORTED ADVERTISING. 300 HOPEFUL PEOPLE SWARMED HERE AND A POST OFFICE WAS ESTABLISHED IN AUGUST, 1926. IN FEBRUARY 1927, THE POST OFFICE CLOSED AND THE TOWN DIED.

[LEADFIELD

THIS WAS A MINING BOOM TOWN FOUNDED
ON WILD AND DISTORTED ADVERTISING. 300
HOPEFUL PEOPLE SWARMED HERE AND A POST
OFFICE WAS ESTABLISHED IN AUGUST,
1926. IN FEBRUARY 1927, THE POST
OFFICE CLOSED AND THE TOWN DIED.]

End Notes

1 Foucault, Michel, 'Preface to Transgression,' In Language, Counter-Memory, Practice, Ithaca, New York: Cornell University Press, 1977, p.148

2 Olson, Charles, 'Projective Verse,' In Selected Writings of Charles Olson, New York: New Directions, 1966, p.20

3 Letter to Porter Garnett dated 15 August 1911, in the Bancroft Library, The University of California, Berkeley, quoted in William Everson, Archetype West: The Pacific Coast as Literary Region, Berkeley: Oyez, p.7

4 Deleuze, Gilles, 'Language: Major and Minor,' In The Deleuze Reader, Ed. Boundas, Constantin; New York: Columbia University Press, 1993, p.145

5 Foucault, Michel, Language, Counter-Memory, Practice, p.37

6 Nietzsche, Friedrich, On The Genealogy of Morals, New York: Vintage, 1989, p.119

7 Ibid.

8 Ibid.

9 Ibid.

10 Joyce, James, A Portrait of the Artist as a Young Man, New York: Viking, 1969, p.79

Bibliography

Bataille, George, 'Visions of Excess: Selected Writings, 1927—1939,'
Trans. Stoekl, Allan; Lovitt, Carl; and Leslie Jr., Donald; Theory and History of Literature, Vol.14,
Minneapolis: University of Minnesota Press, 1985

Bergson, Henri, Matter and Memory, Trans. Paul, Margaret and Palmer, W. Scott; London: George Allen & Unwin, 1929

Bergson, Henri, Time and Free Will: An Essay on the Immediate Data of Consciousness. Trans. Pogson, F.L;
London: George Allen & Unwin, 1910

Bohm, David, Wholeness and the Implicate Order, London: Routledge & Kegan Paul, 1980

Burke, Edmund, A Philosophical Enquiry into the Origin of our Ideas of the Sublime and Beautiful, Oxford, Oxford
University Press, 1958

Chomsky, Noam, Cartesian Linguistics: A Chapter in the History of Rationalist Thought, New York: Harper & Row, 1966

Deleuze, Giles, Nietzsche and Philosophy, Trans. Tomlinson, Hugh; New York: Columbia University Press, 1983

Deleuze, Giles and Guattari, Felix, A Thousand Plateaus, Trans. Massumi, Brian;
Minneapolis: University of Minnesota Press, 1987

Derrida, Jacques, Of Grammatology, Trans. Spivak, Gayatri Chakrovorty; Baltimore: Johns Hopkins, 1976

Derrida, Jacques, Writing and Difference, Trans. Bass, Alan; Illinois: University of Chicago, 1978

Eckhart, Meister, The Essential Sermons, Commentaries, Treatises, and Defense, Trans. McGinn, Bernard;
New York: Paulist Press, 1985

Foucault, Michel, The Archaeology of Knowledge, and the Discourse on Language,
Trans. Smith, Sheridan; New York: Pantheon Books, 1972

Foucault, Michel, The Order of Things, New York: Pantheon Books, 1970

Freud, Sigmund, The Interpretation of Dreams, Trans. Strachey, James; New York: Basic Books, 1955

Hegel, G.W.F, 'Architecture,' in Aesthetics, Lectures on Fine Art, Trans. Knox, T.M;
Oxford: Clarendon Press, 1975

Hoffman, Edward, The Hebrew Alphabet: A Mystical Journey, San Francisco: Chronicle Books, 1998

Husserl, Edmund, Cartesian Meditations: An Introduction to Phenomenology, The Hague: Martinus Nijhoff, 1973

Jameson, Fredric, Post-modernism or, The Cultural Logic of Late Capitalism, Durham: Duke University Press, 1991

Lewin, Kurt, Field Theory in Social Science, New York: Harper, 1951

Kant, Immanuel, Critique of Aesthetic Judgement, Trans. Meredith, J.C; Oxford: Oxford University Press, 1911

Marx, Karl, The Marx-Engels Reader, Ed. Tucker, Robert; New York: Norton, 1978

Nietszche, Frederic, Human, All Too Human: A Book of Free Spirits, Trans. Hollingdale, R.J;
Cambridge: Cambridge University Press, 1986

Olson, Charles, Selected Writings, Ed. Creeley, Robert; New York: New Directions, 1966

Piaget, Jean, The Construction of Reality in the Child, New York: Basic Books, 1954

Plato, The Collected Dialogues, Eds. Hamilton, Edith and Cairns, Huntington; Princeton: Princeton University Press, 1961

Schelling, F.W.J, The Philosophy of Art: An Oration on the Relation Between the Plastic Art and Nature,
Trans. Johnson, A; Minneapolis: University of Minneapolis Press, 1845

Schiller, Freidrich, On the Sublime, Trans. Elias, Julius; New York: Ungar, 1966

Schopenauer, Erwin, The World as Will and Representation, Trans. Haldane, R.B. and Kemp, John;
London: Kegan Paul, 1898

Wittgenstein, Ludwig, Philosophical Investigations, Trans. Anscombe, G.E.M; New York: Macmillan, 1958.

The Bible, New American Standard Edition, Ed. Holman, A.J; Philadephia: 1975

Cover and back cover	'fire creatures,' digital image, 1998 and 'reish' drawing, hebrew character symbolizing higher consciousness, great intuition, and the root words of 'wind' and 'breath'
Title page	still frame from 'the more things change: big bang movie,' aspen design conference, 2001, pentagram LA
001	'april and the small tourist at zabriskie point,' photo: michael rotondi, 2000
002	'curves ahead,' death valley, california, 2000
003	'rock without roll,' digital image, 2000
004	'ayin,' drawing, hebrew character symbolizing perception and insight
005	'trethevy' digital image, quoit in cornwall, england, 2001
006	'howdy hand,' digital image, 1999
007	'does it make sense? design quarterly #133,' walker art center and MIT press publishers, 1986
008	'does it make sense? design quarterly #133,' detail and rework
009-013	'graphic design in america billboard' still frames from 'the more things change: big bang movie,' aspen design conference, 2001
014-015	'pixel bomb,' digital image and detail, 1999
016	'last pict at los alamos,' 1998
017-019	'graphic design in america billboard,' walker art center, minneapolis, 1989 and still frame from 'the more things change' movie, pentagram LA
020	'progress, freedom, equality' still frame from 'the more things change: 19th amendment commemorative stamp' movie, pentagram LA
021-022	'US commemorative postage stamp, 19th amendment,' © US postal service 1995, stamp and detail
023	'joshua, lifetime,' still frame from 'the more things change' digital video, lifetime television, 1987
024	'SCI-ARC pixel architecture animation,' inverted still frame from 'the more things change: southern california institute of architecture,' digital video
025	'SCI-ARC pixel architecture animation,' still frame from 'the more things change' digital video
026	'SCI-ARC identity,' business card detail, southern california institute of architecture, 1989
027-031	'SCI-ARC web animation' stills, 1999
032	'sacred sky-circle,' monument valley, utah, 1993, photo: michael rotondi
033	'hurlers,' digital image, quoit in cornwall, england, 2001
034	'nicola restaurant, garden image,' billboard, los angeles, california, 1994
035	'limited sight distance,' digital image, desert hot springs, california, 2000
036	'coop himmelblau identity,' cloud image detail, 1990
037	'coop himmelblau identity,' letterhead rework, 2000
038	'trethevy,' digital image, quoit in cornwall, england, 2001
039	'RoTo architects identity,' upgrade image, 2000
040-041	RoTo architects letterhead and #10 envelope, 2000
042	'cube mandala,' suzhou, china, 1997
043	still frame from 'the more things change' selby gallery poster movie, 2001
044	'selby gallery, ringling school of art,' poster, 1999
045	still frame from 'the more things change: selby gallery poster movie,' 2001
046-050	still frames from 'the more things change: light is always looking for a body movie,' 2001
051	'point of interest,' death valley, california, 1995

on the following RoTo Architects projects we were responsible for color, finishes and materials:

052-053	'dorland mountain arts colony: front porch,' temecula, california, project: RoTo Architects, original photo: assassi productions, 1996
054-055	'dorland mountain arts colony: nature palette' images, 1995
056	'dorland mountain arts colony: ceiling detail,' original photo: assassi productions, 1996
057	'dorland mountain arts colony: nature palette' image, 1995
058-059	'dorland mountain arts colony: interior space towards bedroom,' original photo: assassi productions, 1996
060-061	'carlson/reges residence,' los angeles, california, project: RoTo Architects, original photo: benny chan fotoworks, 1997
062-064	'carlson/reges residence: main space,' digital images, 2001
065	'carlson/reges residence: lichen palette,' digital image, 1996
066	'carlson/reges residence: main space,' original photo: john lodge, 2001
067	'carlson/reges residence: lichen palette,' digital image, 1996
068-069	'sinte gleska university technology building,' digital image, rosebud reservation, antelope, south dakota, project: RoTo Architects 1998
070-071	'sinte gleska university technology building: downstairs entrance corridor and upstairs bridge corridor,' digital images, 1998
072	'badland grasses,' badlands, south dakota, 1996
073	'badland sign,' badlands national monument, south dakota, 1996
074	'sinte gleska university technology building: looking through circular meeting room towards pasture lands,' digital image, 1997
075	'sinte gleska university technology building: circular meeting room,' digital image, 1997
076-077	'wherehouse c: the lantern,' nagasaki, japan, original photo: shinkenchikusha, 1997
078	'wherehouse c: o-sphero and green panel,' original photo: kyusyu, 1997
079	'wherehouse c: o-sphero and roof,' original photo: kyusyu, 1997
080	'wherehouse c: side view and platform looking south,' original photo: kyusyu, 1997

158

081 'caution, one way road both ways,' pioneertown, california, 2001
082 'windmills along the ten,' digital image, north palm springs, california, 2001
083 'driving through the pass,' digital image, beaumont, california, 1999
084 'driving to the manor,' digital image, desert hot springs, california, 1998
085 'miracle manor sign,' digital image, desert hot springs, california, 1996
086 'barrel cactus,' digital image, miracle manor retreat, desert hot springs, california, 1997
087 'pool water,' digital image, miracle manor retreat, desert hot springs, california, 1997
088 'mem,' hebrew letter symbolizing water, and the vast sea of our human consciousness containing depths concealed from view;
 also the number forty, signifying the length of time necessary for a cycle to reach fruition
089 'miraclemanor.com icons,' miracle manor retreat website, 2000
090-091 'view from our room with that cloud,' miracle manor retreat, desert hot springs, california,1999 and still frame from 'the more things change, miracle
 manor movie,' 2001
092 'cactus and pool,' still frame from 'the more things change: miracle manor movie,' 2001
093 'view of joshua tree,' highway 62, california, digital image, 2001
094-095 'view of desert hot springs from aerial tram,' digital image and detail, mount san jacinto, palm springs, california, 1999
096 'room #2 and organic cotton,' still frame from 'the more things change: miracle manor movie,' 2001
097 'organic wool,' image detail, miracle manor retreat, desert hot springs, california, 1999
098 'cactus bloom with bugs,' digital image, joshua tree, california, 2001
099 'cholla abstract,' digital image detail, desert hot springs, california, 1999
100 'pixel vase and shadow,' digital image, miracle manor retreat, desert hot springs, california, 1996
101 'vase and shadow,' miracle manor retreat, desert hot springs, california, 1996
102 'our room,' miracle manor retreat, desert hot springs, california, original photo: john lodge, 1996
103 'flying mattress,' miracle manor retreat, desert hot springs, california, photo/digital image: with jeff miller, 1996
104-107 'organic cotton, pump, mattress and no shark,' images/postcard series, miracle manor retreat, 2001
108 'pump, in the middle of the desert,' postcard, miracle manor retreat, 2001
109 'the wash rocks,' digital image, desert hot springs, california, 2001
110 'creosote and cloud,' digital image, desert hot springs, california, 2001
111 'cabot's museum and that bizarre totem,' digital image, desert hot springs, california, 2001
112 'our new property facing joshua,' digital image, desert hot springs, california, 2001
113 'pool at dusk,' miracle manor retreat, desert hot springs, california, original photo: john lodge, 2001
114-118 'the hurlers,' digital image, liskeard, cornwall, england, 2001
119 'one sheep,' digital image, near liskeard, cornwall, england, 2001
120 'leadfield,' digital image, death valley, california, 1999
121 'tuscany bus-stop,' digital image, near volterra, italy, 2001
122 'homesteader's house,' digital image, pioneertown, california, 2000
123 'beit,' hebrew letter associated with a house, dwelling place for the divine, primal, receptive energy; the universal home, infinite womb of fertility,
 from which everything is born and nourished; begins the root words for holy temple, places of study, social gathering and prayer
last page 'command Z,' symbol image, 2000

121
122
123

and,
Aris, you are a genius! I feel, as I do with Michael, that I don't deserve you, or your writing.
Your words have touched me deeply and made my work take flight.

I would like to thank,
from the heart of my heart, the current Pentagram(mers): Adrianna Day, Jeniffer González (who produced this
book,) Jane and Gordon Hein, and James Huang. They have all been
true collaborators and contributors in the creative process.

Also, a very special thanks to
Jeff Miller, James Campbell, Atsushi Ishizuka, Brian Barth, Yasmin
Khan, Hazel Lee, and many others...

Retreat
Finally, my boyfriend mike, partner in Miracle Manor
and pal on the path - for the inspired architectural
projects to collaborate on color, finishes, materials,
but also for the special creative alliance, which comes
with its innate difficulties, only to be surpassed by
the incredible process of discovery and joy we share.
So far our journey has been both amazing and humbling.
Michael, I thank you and love you.

Others who have helped beyond
the call of duty, (and seem to want
to continue:) Jan Angevine, Sofia
Angkasa, Michael Dobry, Bob
Engelsiepen, Mildred Friedman,
Dale Herigstad, Bon of La Mancha
Lyman, Harry Marks, Eric Martin,
Neal Izum and Adrian (down the
hall) Velicescu.

and that Pro-(whatta guy) Lewis,
who jumped in and provided the most tender, insightful foreword I could have ever imagined, with only a split-
second's notice, giving this book its only "white space," which was (is) desperately missing.

On the RotoVision frontlines—
my gratitude to Natalia Price-Cabrera (the originator of this fine book idea with me and RotoVision), Kate Noël-Paton and Luke Herriot for their for their valiant efforts in keeping this
together and actually making the deadline. This could not have been accomplished without their ample senses of humor, only to be matched by their patience and intelligence.

love and deep appreciation
to the
flying-greimans:
rene and jack
paul
audrey and charles
lenore and murray

who have all continued
to help in their unique
and various ways
(sometimes without
ever having touched
the ground).

and, oh,
armin and dorothé hofmann, and wolfgang weingart
for launching me into orbit, many, many thanks for your patience
and encouragement as a youngster with only raw energy.

and to those health practitioners, who attempt to keep my body aligned with my spirit:
Dr. Latif Allen, Dr. Marsha Connor, Tahlia Fischer, Mary Jo Frazier and Licia Perea.

< over and out >